ARTIST'S PROJECTS YOU CAN PAINT

10 Experiments With Impressionism En Plein Air

by Betty J. Billups

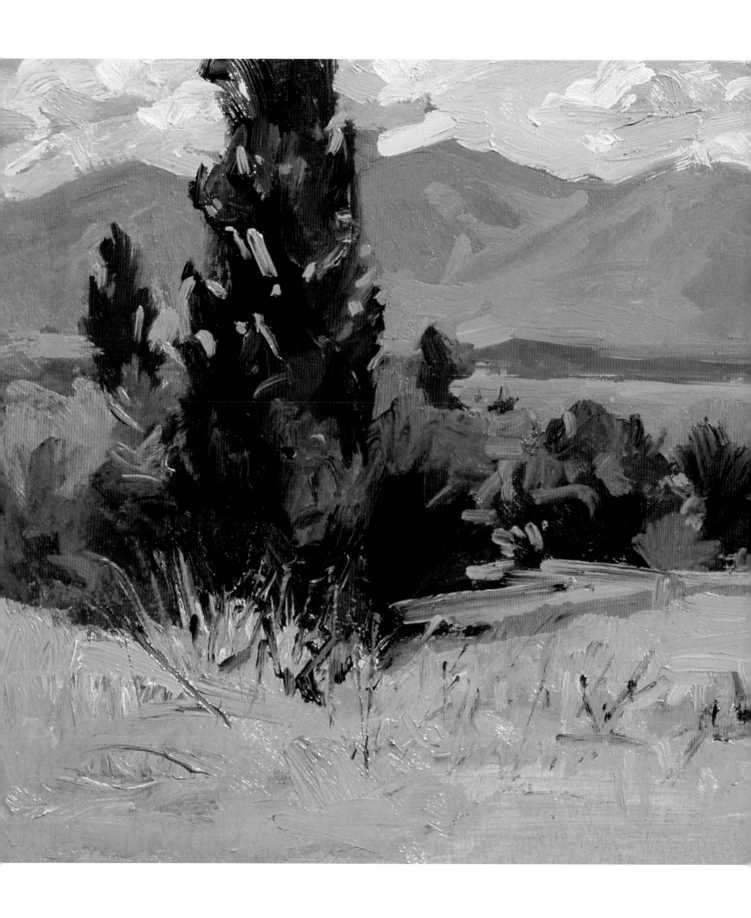

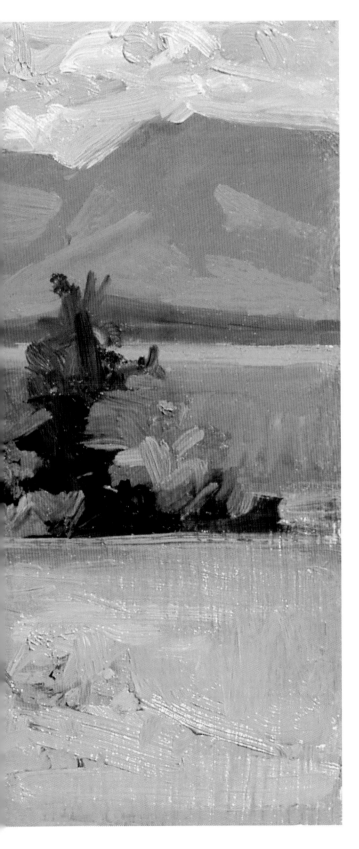

ARTIST'S PROJECTS YOU CAN PAINT

10 Experiments With Impressionism En Plein Air

by Betty J. Billups

International Artist Publishing, Inc.
2775 Old Highway 40
P.O. Box 1450
Verdi, Nevada 89439

Website: www.internationalartist.com

Edited by Jennifer S. Hollingsworth
Designed by Vincent Miller
Typeset by G. Reid Helms

ISBN-1-929834-54-3

Printed in Hong Kong
First printed in paperback 2005
09 08 07 06 05 6 5 4 3 2 1

Distributed to the trade and art markets
in North America by:
North Light Books,
an imprint of F&W Publications, Inc
4700 East Galbraith Road
Cincinnati, OH 45236
(800) 289-0963

Dedication

This book is dedicated to all who have brought me through the trying times of this marvelous journey: My beloved Dad who always found simple answers to complicated things, my Mom whose love of her family goes to eternity, Reynold Brown who "plugged me in" with desire to learn, Joseph Morgan Henninger and his beloved wife Danica whose unconditional love and belief in me brought me to heights I never dreamed of before and to each and every person who has shown enthusiasm and love for my work, helping me realize that what I felt and captured did have an effect on those around me.

Acknowledgments

I'd like to thank Bill and Elfrieda Mullin, who are among my foremost patrons, and who also gave me the opportunity to buy my first home which gave me a stability and security I've seldom known. My thanks also go to Dan McCaw for the years he opened his studio for me and for his passion, compassion and kindness he extended to me, which without I wouldn't be the artist I am today. I also extend a great deal of gratitude to Joyce Fenton whose enthusiasm and support regarding my art was like spring rain in an arid desert — the blooms that have developed have been endless!

I extend special thanks to Jennifer Hollingsworth for her great editing and kindness toward the tight deadline I created for her, and my deepest thanks to Vincent Miller and Terri Dodd for giving me the opportunity of a lifetime in asking me to write this publication. They'll never know how it has lifted my spirit and allowed a deep and longing dream to come true — to share that which I have gleaned from life and art with others on the same journey.

Evening Repose

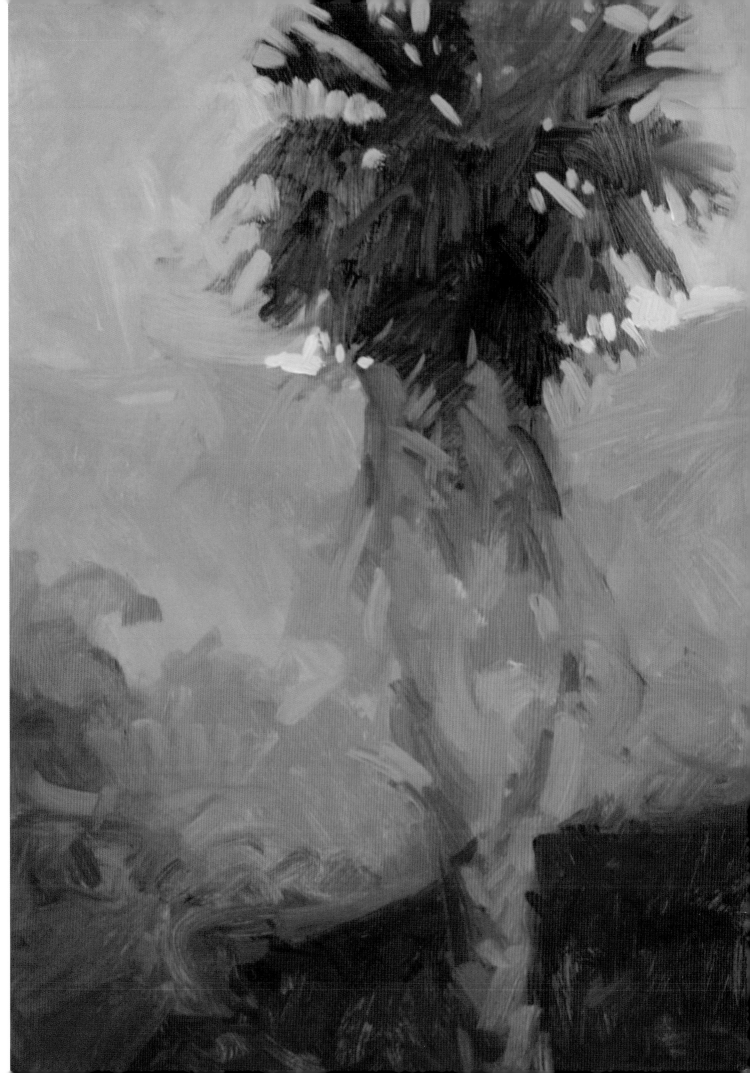

CONTENTS

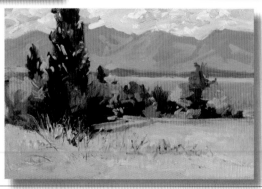

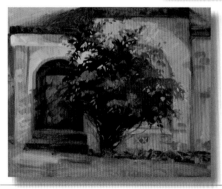

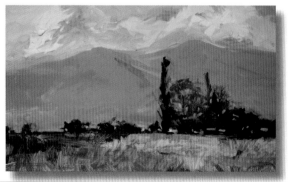

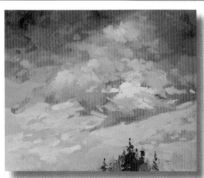

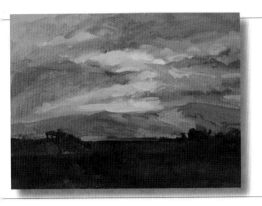
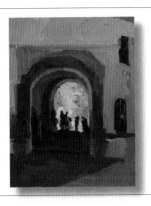
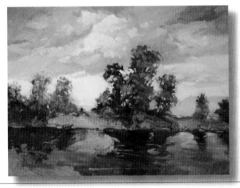
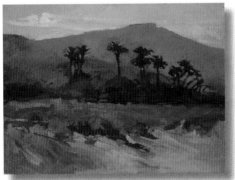
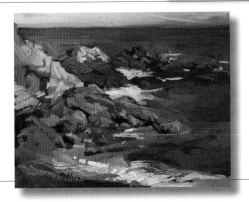

INTRODUCTION

This book is full of major fundamental principles that I call "no brainers." These principles will guide you in simplifying shapes, mastering tonal values and understanding light so that you may use the Impressionistic style to paint subjects in a loosely structured, romantic fashion. While I paint en plein air, or outdoors, these projects are designed to be practiced indoors. After you feel comfortable with the basics, you can venture outside to use them in your own plein air painting session.

The difference in how we personally interpret these principles is what makes our work unique! It's important to understand that there are no absolutes in art. No one style is better than another.

Everything in life is basically simple. In music there are eight musical notes, but millions of songs! In painting, there are basically the three values of light, medium and dark, and the three primary colors of red, yellow and blue. Every photograph and painting ever created has these six elements or less involved in them.

Good design and compositions are just as simple. It should be your goal to see if you can make your own statement using the ideas and elements in the artwork shown here, not to see how closely you can copy the work. Use your own voice, whatever that may be.

Using your own artistic voice

I believe it should be a teacher's goal to help a student climb their own ladder, and at the end of a session those students should be two, three or four rungs higher on their ladders — not that of the teacher's! You may copy what you see here, and feel that you are an artist if your paintings look just exactly like the ones in the book, but know that it's just a physical accomplishment. It has little to do with creativity, because creativity comes from the unknown. What a shame it would be if you were to lose your creative voice while studying how to find it.

Your painting is a discovery of something that never existed prior. If you can understand the thinking behind the painting and beyond all the words and explanations that you find here, then you are on your way to arriving at the artistic level you so deeply want. You already have within you all that you need: belief and desire!

This journey to you is a forever thing. Just when you think you have arrived or when your ego gets the best of you is when you'll fall on your face. However, if you ever really arrive, then you'll have lost the edge to discovery. The more I study, the more I realize how little I know. All the knowledge and know-how in the world won't guarantee a great painting. In the unknown, we are shoved to the edge, not to fall, but to learn to fly!

Above all else, have fun. Joy is one of the main elements in life, and it's essential to discovering beauty. Beauty is in your art, and beauty is within you. There isn't a human being on this earth who doesn't have greatness coursing through their veins — greatness that can be a blessing to all

who come in contact with it. When we discover the beauty that surrounds us maybe then we can work to create peace on earth.

Staying true to yourself

More important than all the knowledge of how to properly apply paint is passion. Never let anyone, nor anything rob you of it. Remember that a painting has to be loved into existence. Like anything else in life worth doing, paint with all that is precious within you.

When you study with anyone, know that your quest should be to gather information that best energizes you, and best reflects what it is that you want to say with your art expression. No teacher should ever make you feel small or not important due to your own personal quest.

Each of us has something very special to offer the world that might just help heal the hurt that causes so much of the world's pain. Always be true to yourself, finding the joy, excitement and adventure in your expression. Remember that the only thing worse than copying another person's style or statement is to copy yourself. The day you find a formula for anything in your art is the day your art will begin to die. How can you be creative if you already know the answer?

Some people want to make statements about the ugliness in the world and they spend their energy capturing the ugly and the tasteless — that is fine. But only beauty can make the world better as you help others see the great world they already have around them, even on an overcast day and in the most mundane of elements. That's my passion and my reason to paint, and the reason I want to share all the things that I've gleaned from this wonderful thing we call life.

Why paint en plein air?

In 1985 when Denise Burns invited me to be a member of a group she was creating called Plein Air Painters of America (PAPA), neither of us realized it would be the "papa" of the now popular American and worldwide trend of artists venturing out into nature to paint outdoors.

As I look back over the years, I see that Denise was right. It's important for us to go out and capture the beauty of our world before it's destroyed by developers or even natural disasters. There are a number of scenes that can never be painted again in this book. One very dear to my heart is Sand Creek, which depicts a beautiful creek flowing through a small northern Idaho town. In the months ahead a huge retaining wall is set to be erected in the creek in order to hold concrete supports for a bypass. Yes, it might regulate the traffic on the town's streets, but the original beauty of the creek will be gone, leaving man's scar on civilization.

It's for these reasons that artists need to go out and document the beauty before it's gone forever. Hopefully, your art may bring more public awareness to those with the deciding vote.

Materials you will need to paint every project in this book

The most important thing in any learning process is you — your passion, your desire, your time and your open mind. That's why it's important not to skimp on supplies. Always use artist's quality paints and brushes. If you cut corners, you'll spend your time being frustrated instead of learning.

Regarding the size of support to use, you can either use the size I used for the individual projects or you can us a smaller canvas as long as it has the same inch difference between the height and width. For example, if I use a 16 x 20" support, you can use a 12 x 16" support because they both have a height to width difference of four inches.

Support

Artist's quality canvas board

Brushes

Medium filberts Nos. 6 and 8
Small filberts Nos. 2 and 4
Medium rounds Nos. 6 and 8
Small rounds Nos. 2 and 4

Other materials

Plexiglass palette
Medium palette knife
Scraper for palette
Odorless paint thinner
Paper towels

Filberts

Rounds

12 Artist's quality oils

TITANIUM
WHITE

LEMON
YELLOW

RAW
SIENNA

BURNT
SIENNA

NAPTHOL
RED

QUINACRIDONE
RED

ALIZARIN
CRIMSON

PERMANENT
GREEN LIGHT

PHTHALO
GREEN

FRENCH
ULTRAMARINE

PHTHALO
BLUE

CERULEAN
BLUE

When you're ready to paint en plein air

When you take your "studio" to a location to paint from life, it's best and less frustrating if you keep it simple and lightweight so you aren't exhausted by the time you get to your location. Also keep in mind that when painting on location you may have to deal with wind, sun, heat, cold, rain, bugs and dust.

Using a **pochade** on location is ideal. French for "painting box," this lightweight box is designed to set up as an easel and hold many of the essentials that you need on location. Although some pochades are more basic than others, I designed one that has room to store paint on the palette between locations and hold six wet paintings. If your pochade isn't this roomy, you'll need to carry a dry box for the wet paintings. Make sure that your pochade can be repaired because most wooden equipment will eventually break for one reason or another. If you already have a french easel you can use that, but I don't suggest buying one because they're generally heavy and bulky. I've created over 1,000 paintings from my pochade set-up.

You'll need a lightweight quick-release **tripod** to support the pochade. The best ones are more expensive, but are all-metal with legs that lock with the flip-tab. The best thing to do is take your pochade with you when purchasing the tripod to see how it fits. Test it by pushing the box to ensure that it doesn't bounce.

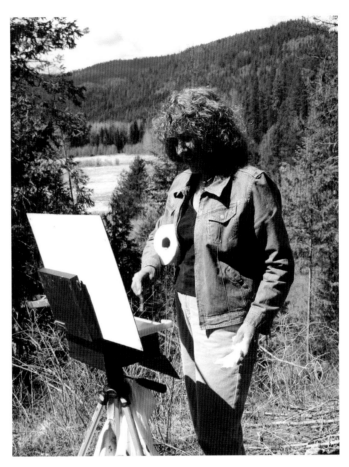

You'll also need a **backpack** to hold all the equipment. An Army/Navy surplus store may have a backpack that fits the bill. Take your pochade and tripod on your trip to find the backpack and make sure that both will fit into it. A top zipper area is handy to store items such as bungee cords, which you can use on location to attach your paper towels under your pochade. You can also use them to counter weight your set-up with a weighted object such as a rock so that it isn't easily blown over by the wind.

The brushes I use are usually bristle **filberts** and **rounds** in sizes 2 through 10. I keep one or two **flat** brushes for buildings, or when I want a more manmade edge. I also use a **rigger** brush — a long, thin sable that is useful for holding and delivering a lot of paint in a long thin line. I use a medium-sized **palette knife** for mixing large amounts of pigment on my palette, for clearing the palette when too much used paint accumulates and for scraping the panel when things need to be simplified. Be sure they are flexible and easy to work with.

While I paint on birch door skins and museum board, I advise that as a beginner you paint on **artist's quality canvas board** or other smooth surface. Besides being more affordable, these are easier to carry on location. The only medium I use is a dab of odorless **paint thinner** to make my pigments move easily, but not be drippy. I figure there is enough medium in the pigment without adding more.

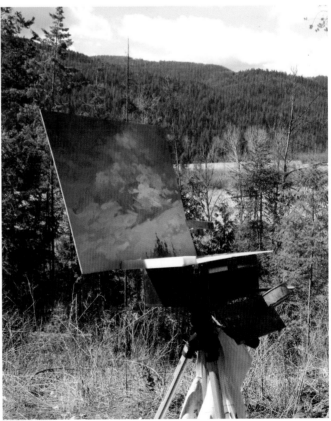

Though an **umbrella** can be cumbersome and challenging to carry or set up, shade is important when painting outside. Keeping your palette and painting out of direct sunlight is important to find the correct values. I personally don't carry my shade, but find it while painting even if it means using my body to shade my work.

Be sure to take paper towels and trash bags on location. I usually tie the bag onto my tripod. My gift back to the view that I've captured is that I'll pick up any debris I find at the location. I feel it's essential to give something back for the gift of beauty it has given to us. It keeps the circle of life whole!

Photography by Bobbie Johnson

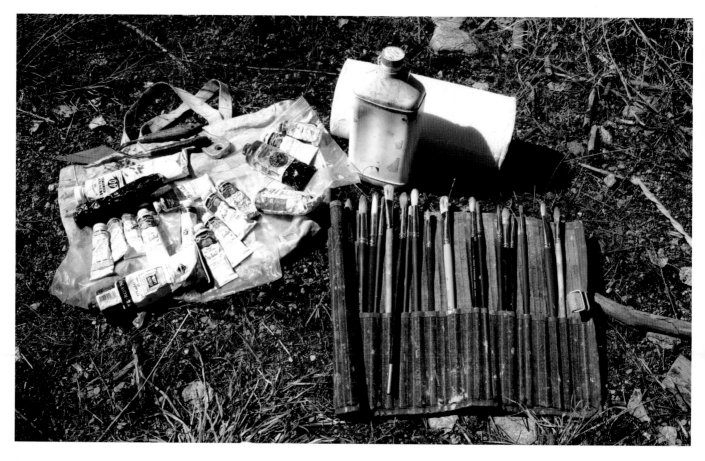

Items to take on location

Backpack
Pochade
Dry box
Tripod
Support
Umbrella
Apron
Paper towels
Trash bags

Glass scraper
Palette knife
Small bottle of thinner
Canvas roll to hold brushes
Bungee cords to balance tripod
Nos. 2 – 10 round and filbert brushes
Small tin can to hold thinner while painting
Zip-lock bags to organize your paint tubes
Canvas tote to carry tubes of paint

Cleaning brushes

Work up a small lather in the palm of your hand
with some mild bar soap, then move the brush
back and forth, coating the bristles with soap.
Pulling from the metal out, work the soap and
pigment out of the brush, rinsing as you do.
Wipe the brush with a paper towel until no
residue shows on the towel.

Color mixes

Notice how you can achieve several different colors by mixing pure colors.

PHTHALO GREEN + BURNT SIENNA

PHTHALO GREEN + ALIZARIN CRIMSON

PHTHALO GREEN + PHTHALO RED ROSE

PHTHALO GREEN + NAPTHOL RED

LEMON YELLOW + BURNT SIENNA

LEMON YELLOW + NAPTHOL RED

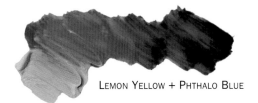

LEMON YELLOW + PHTHALO BLUE

LEMON YELLOW + FRENCH ULTRAMARINE

Managing your palette

Your palette should be big enough to mix large amounts of pigment while painting. My personal experience is that a palette equal to the size of your support is excellent. If that's not possible, use a palette that's no less than half the size of the support. If you're painting on a 12 x 16" support, use a palette that's at least 8 x 10".

Always place your pigments in the same location on your palette. It's difficult enough figuring out what to do without searching for your paint! Your paint and brushes should be an extension of your arm, without a second thought to them once you start painting. There are many different ways of laying out your paints — just do what works best for you. I lay out my pigments in color value order: white, light yellow, dark yellow, earth yellow, earth red, light red, dark red, rose and Phthalo Reds, light green, dark green, light blue, dark blue and black. While I don't suggest that beginners use black, it can be marvelous when used properly.

If your painting is looking muddy, look at your palette because it's probably muddy too. As you're working, clean your palette often using your glass scraper. Save this paint in a pile and mix it thoroughly using your palette knife for a palette gray that's useful for blocking in shapes or toning down values.

If your piles of pigment are too dirty to get clean paint from them, then use your palette knife to pull the similar colors into separate piles of color and mix thoroughly. Lay them back in a second row in front of the pure colors. Some of your best paintings will be created out of these wonderful mixes!

PROJECT 1 LIGHT ON YONDER HILL

Creating impact with basic design and color values

This project will show you how to paint a simple design using light, medium and dark values.

The challenges

Values are an important part of a finished painting. All the paintings ever created range between the values of 0 (black) to 10 (white). That being said, this should be a simple matter! But values are perhaps one of the biggest stumbling blocks of many artists. Your challenge is to establish a strong three-value pattern for your painting because using the full range of 10 values often results in a weak and very repetitive finish. While you can have unlimited colors within each value area, you have to assign one basic value to each section of your painting if you want a strong design. You will use three distinct values: light, medium and dark.

What you'll learn

- How to make major corrections
- How to keep the painting within a three-value range without strong dark or light values

Before you begin, read the entire project through so you know what's going to happen in each stage.

Dark				Medium			Light			
0	1	2	3	4	5	6	7	8	9	10

Values

Value is the lightness or darkness of any color. The darkest value is 0 (black) and the lightest value is 10 (white). Using values correctly is essential because they give a painting depth and dimension and create movement. For example, you could use a 3, 5 and 7 to create a three-value painting. Study the light, medium and dark values of the violet color and use this example to paint the project.

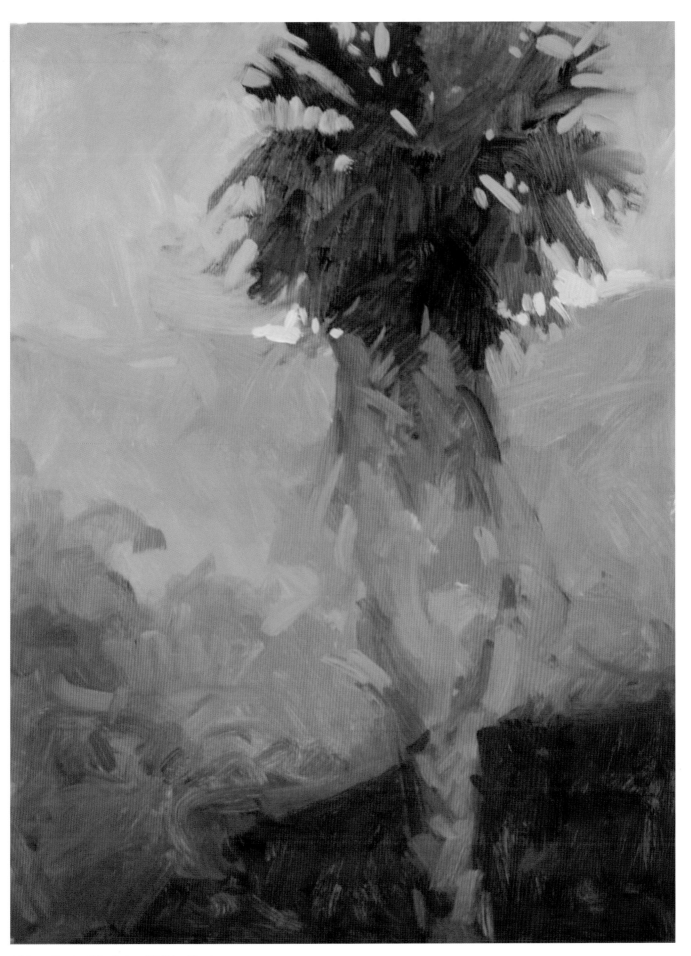

Light on Yonder Hill, oil, 16 x 12" (41 x 30cm)

The materials you'll need for this project

Support
Artist's quality canvas board

Brushes
Nos. 2, 4 and 6 filberts
Nos. 4 and 6 rounds

Other Materials
Paint thinner
Scraper
Palette knife

Artist's Quality Oils

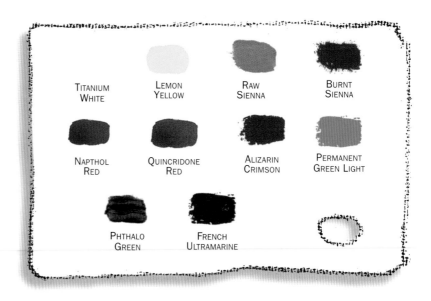

TITANIUM WHITE LEMON YELLOW RAW SIENNA BURNT SIENNA

NAPTHOL RED QUINCRIDONE RED ALIZARIN CRIMSON PERMANENT GREEN LIGHT

PHTHALO GREEN FRENCH ULTRAMARINE

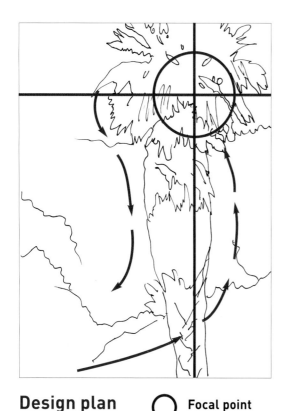

Design plan

◯ Focal point

↶ Eye movement

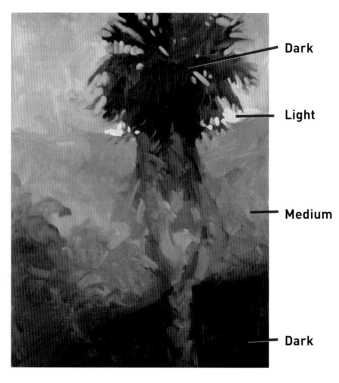

Dark

Light

Medium

Dark

The tonal values in this painting

Step 1

Make a basic drawing

- Mix a thin wash of Burnt Sienna and thinner, then using a dry No. 2 filbert draw the outline of the tree and indicate the main lines for the mountain and foreground contours. Remember that a quality drawing is the foundation for your painting.

NOTE

If you divide your canvas into thirds by lightly marking it as shown, it will help you keep from placing objects in the center and from dividing things in half.

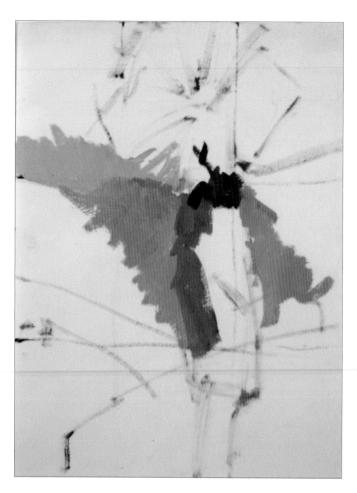

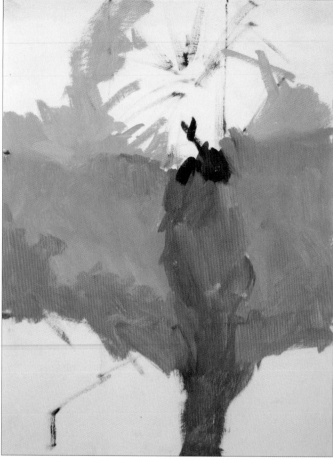

Step 2

Establish the mountain and skirt of tree

- Using a No. 4 filbert, apply a mixture of French Ultramarine, Phthalo Red Rose and a little Titanium White and Napthol Red to the distant mountain.
- Using a No. 4 round, paint the distant mountains on the left with the violet mix, adding more Titanium White and a little Napthol Red.
- Apply a mixture of Burnt Sienna, Raw Sienna and a touch of the violet mix to the skirt of the tree, where the dead leaves fall.

Step 3

Block in basic elements

- Paint the rest of the mountains using a No. 6 round and a blend of Phthalo Green, Lemon Yellow, Titanium White and the violet mix.
- Block in the midground greenery.
- Establish the sky using a small amount of French Ultramarine and palette gray.

FRENCH ULTRAMARINE

QUINACRIDONE RED

Mountain Mix

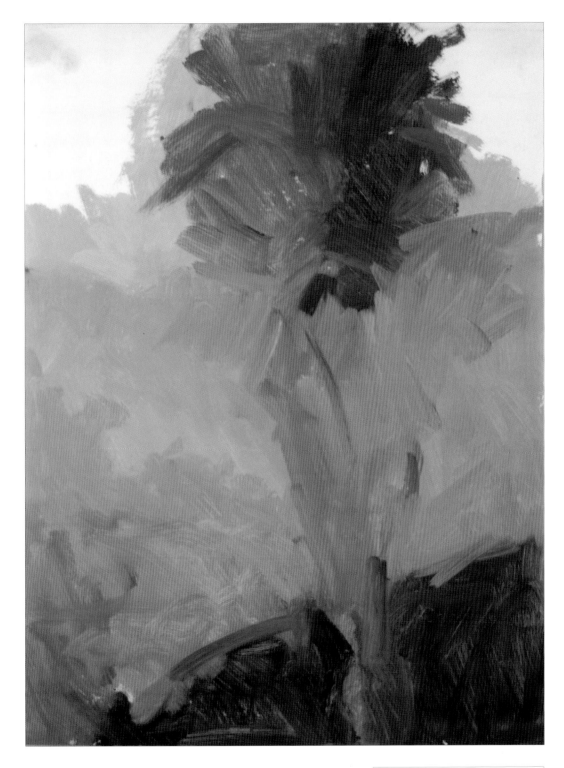

Step 4

Lay in the foreground and palm fronds

- Using a No. 6 filbert, add Burnt Sienna to the corners of the foreground, and put a touch of a blue on the bottom right corner.
- Lay in a dark green for the greenery in the middle of the foreground.
- Establish the palm fronds with a mix of Phthalo Green, Burnt Sienna and Permanent Green Light. Think of the growth pattern of the palm fronds and paint them as they grow, fanning out like feathers.

NOTE

Don't paint inside the lines! Be willing to lose your form to get handsome brushstrokes. You can redefine it later.

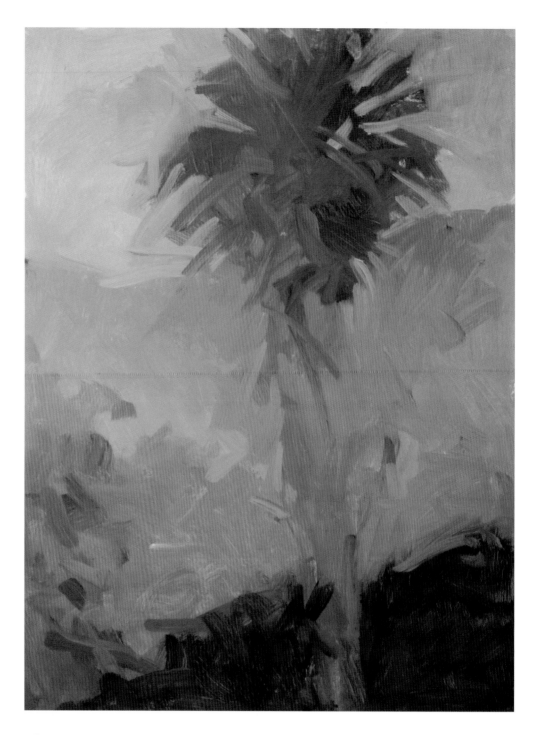

Step 5

Paint the sky and introduce detail

- Using a No. 6 filbert, paint the rest of the sky using the violet mix blended with Titanium White to lighten the value, then accent with the violet mix alone. Note that the sky shifts from warmer on the right side to cooler on the left.

- Introduce some yellow to the midground greenery. Add touches of the violet mix and Phthalo Red Rose around the greenery, trunk, mountains and palm fronds.

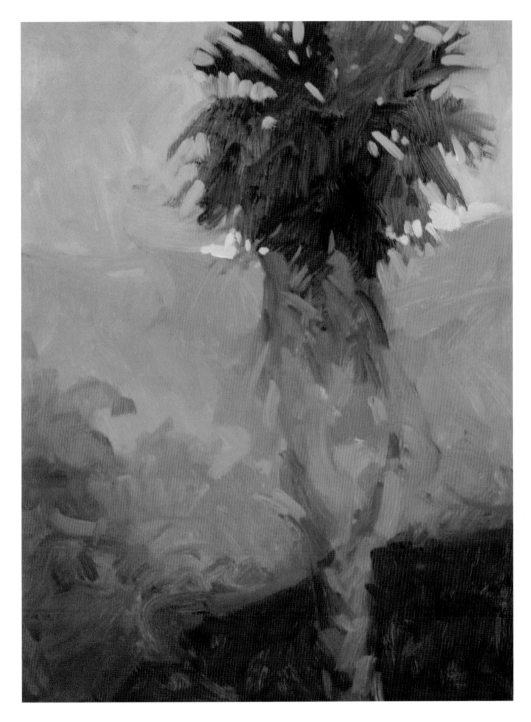

Step 6

Add the finishing touches

- Now I'll show you how easy it is to modify your painting. Using a No. 4 filbert and the sky color mix, paint over the top of the palm tree. Reapply pure Burnt Sienna, painting simple shapes to depict the fronds.

- Mix some sky color and paint the inside silhouettes of the palm fronds with a small brush for detail. Using criss-cross motions paint along the skirt and tree trunk.

- Paint the yellow light at the bottom of the sky at the mountain's edge, laying it in with one pass to keep the color clean. This sky area has the only pure Lemon Yellow and Titanium White in the painting, so it stands out from all of the other colors.

- Hit color notes here and there to add sparkle.

PROJECT 2 FLATHEAD LAKE

Harmonizing with color

This project will show you how to relate colors to one another to create harmony and support the focal point.

The challenges

It's important to understand how colors relate to one another — the key is putting the right spot of color next to another. Painting is very similar to music. While all notes by themselves are beautiful and pure, their placement next to one another is what makes a particular song pleasing or not. Like in music, the area where two colors meet determines the relationship, and hopefully those colors support each other and don't make the painting look too strong, muddy or chalky. Remember that this painting is about a family of plant life and that all other elements support these main actors.

What you'll learn

- How to tone your support
- How to understand color relationships
- How to create three major value areas and keep their integrity

Before you begin, read the entire project through so you know what's going to happen in each stage.

22

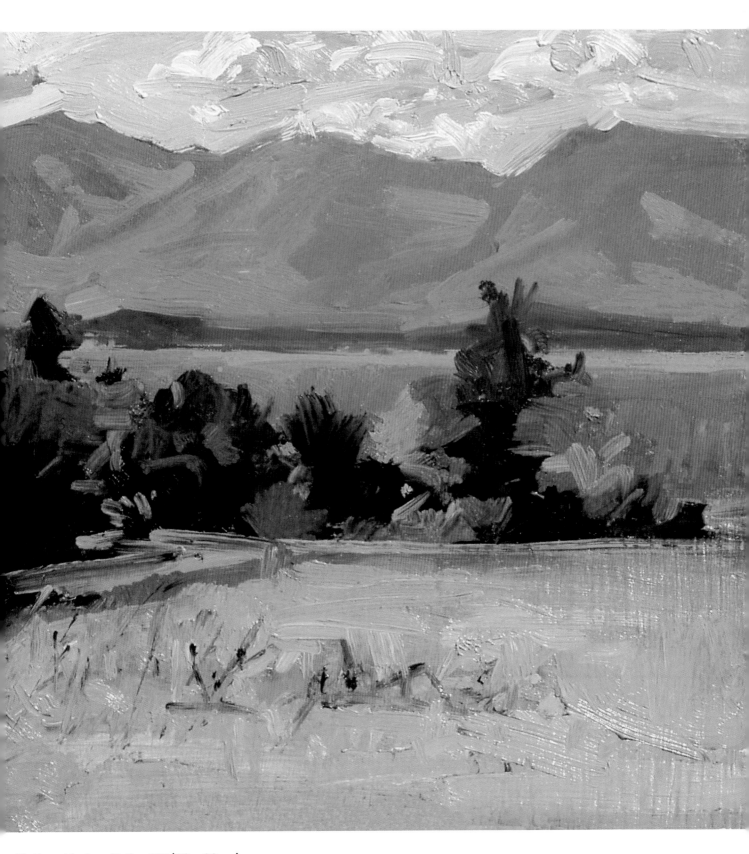

Flathead Lake, oil, 8 x 12" (20 x 30cm)

The materials you'll need for this project

Support
Artist's quality canvas board

Brushes
Nos. 2 and 4 filberts
No. 2 round

Other Materials
Paint thinner
Scraper
Palette Knife

Artist's Quality Oils

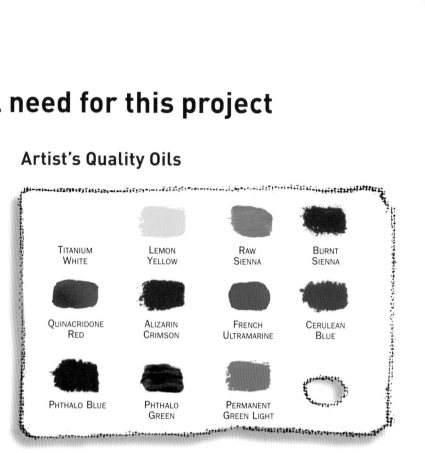

TITANIUM WHITE LEMON YELLOW RAW SIENNA BURNT SIENNA

QUINACRIDONE RED ALIZARIN CRIMSON FRENCH ULTRAMARINE CERULEAN BLUE

PHTHALO BLUE PHTHALO GREEN PERMANENT GREEN LIGHT

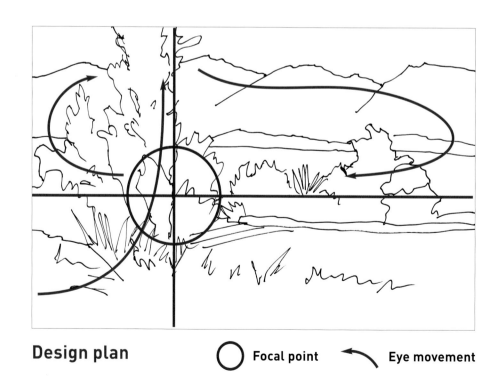

Design plan ○ **Focal point** ← **Eye movement**

Step 1

Tone your support first

- Underpainting your support before you start is beneficial for many reasons, a few being that it establishes a mid-tone immediately and covers all the white of the canvas. Using a large brush or paper towel, apply a thin wash of Burnt Sienna and palette gray, then let it dry.

Step 2

Outline the main shape

- Mix a thin wash of Burnt Sienna and thinner, then using a dry No. 2 filbert lightly draw an outline of the largest tree, base of the mountain and foreground onto your toned support. Use these as reference points to paint all other elements.

- Block in the sky with a mix of Titanium White and French Ultramarine.

> **NOTE**
> Mix large piles of color and apply the paint generously! You'll be pulling from these piles throughout the process.

Step 3

Establish the values of the sky and mountain

- Lay in the mountain using a mix of French Ultramarine and a small amount of Quinacridone Red and Titanium White. These first values of the sky and mountain will establish the key of your entire painting, so they must be as accurate as possible. They have to relate, yet be separate enough to create depth. Beware of making your initial colors too dark or too light because your entire painting will follow that direction.

Step 4

Block in basic elements

- Add clouds to the sky area using a touch of Raw Sienna and Titanium White.

- Suggest dimension by accenting the mountains.

- Block in the largest tree using pure Burnt Sienna, then paint the sunny side with a mix of Permanent Green Light and Lemon Yellow. Depict the shadow side with a mix of French Ultramarine, Phthalo Green and Burnt Sienna.

NOTE

- To make greens darker, add reds, Burnt Sienna and dark blues.

- To make greens lighter, add yellow and Raw Sienna.

- To make a color opaque, add white.

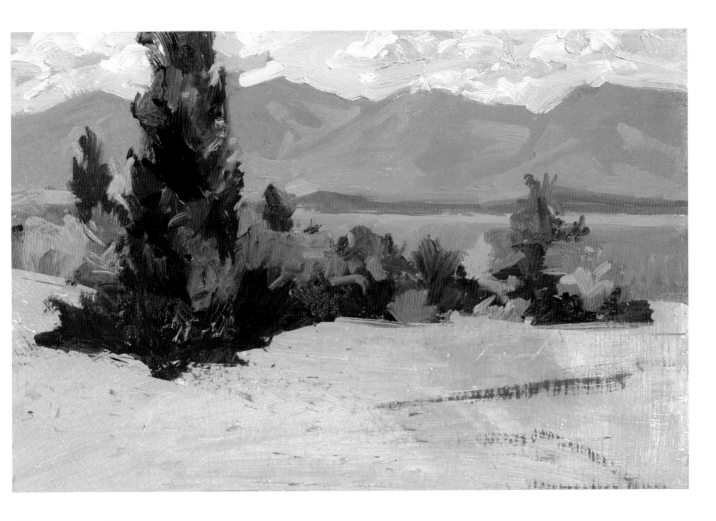

Step 5

Lay in the water and trees

- Using a No. 4 filbert and a rich mix of Phthalo Green and a little Titanium White, lay in the midground water. To create the illusion of space, the water's value must be different enough from the value of the trees. The dark tree supports the strong, pure color of the water.

- Create the line of trees using different shades of green. Add Lemon Yellow or Raw Sienna to Permanent Green Light or Phthalo Green, using Titanium White sparingly. Look at the larger shapes when blocking in color masses and keep the shapes interesting, but remember that the lake's edges are as important as the edges of the trees.

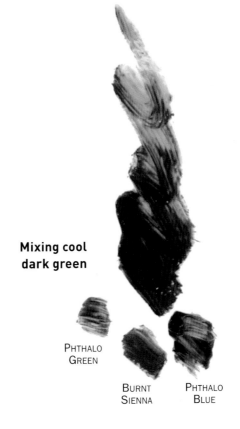

Mixing cool dark green

PHTHALO GREEN

BURNT SIENNA

PHTHALO BLUE

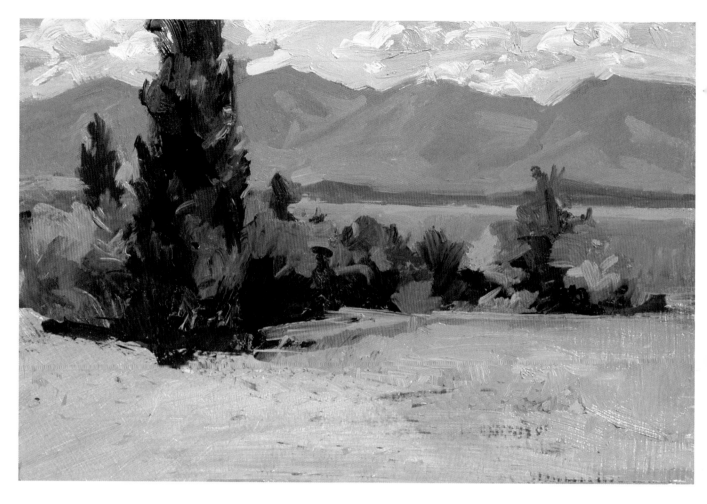

Step 6

Establish the foreground

- Using a mix of green, Raw Sienna and some Titanium White, apply a thin wash to the foreground by the right of the trees. Keep it simple so weeds will stand out when painted later.
- Apply a thin wash of light blue along the right side of the tree line to create a temperature change, thus creating excitement.

NOTE

Don't fuss around with your color. Mix it, load your brush and lay it down.

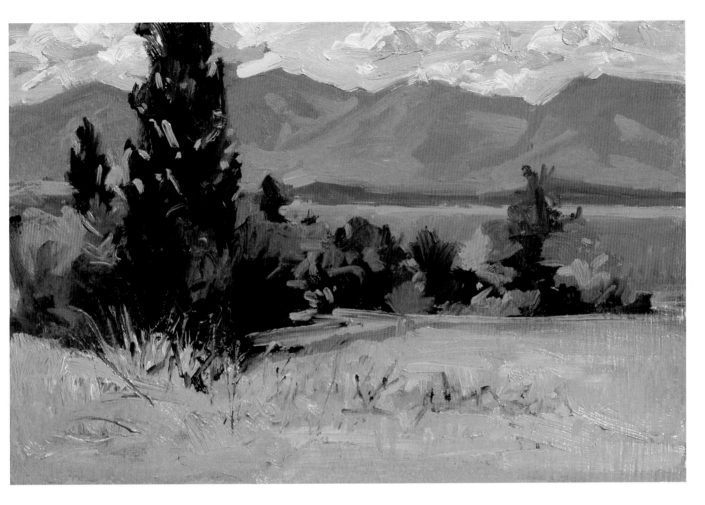

Step 7

Finish with strong shapes

- Warm up the soil areas in the foreground by using a mix of red and a little Raw Sienna, accented with warm yellow. This will separate the extreme foreground from the field behind it.
- Develop the foreground with weeds of varying greens. To break up the greens, use a palette knife to add thick touches of the violet mix.
- Using a No. 2 round, cut sky holes into the trees, reflecting their growth pattern.
- Make any final touch-ups at this stage, simplifying, deleting or accenting. Remember that sometimes less is more!

The tonal values in this painting

PROJECT 3 THE RED DOOR

Using edge and value control to suggest texture

This project will show you how to paint reds in sunlight and how to suggest texture by controlling edges and values.

The challenges

The edge of an object describes its surface to the viewer, whether it's a hard or soft surface. Values are also used to convey quality, as well as the proximity of objects within a painting. The key is using these effectively to create a feeling of different surfaces, depth and dimension. Knowing how to mix different shades of red without producing pink is also a challenge that you can master, as is understanding negative spaces, which is as important as painting the actual or positive spaces.

What you'll learn

- When to soften an edge through brush control or value control
- How to create the effect of sunlight and shadow on a red surface
- When to work transparently and when to work more opaquely

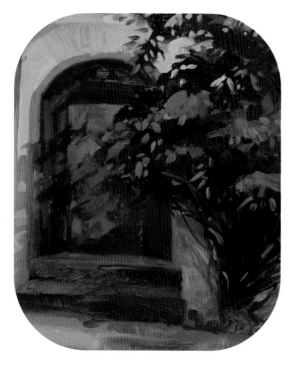

DEFINITIONS

Negative spaces are the unoccupied spaces between the forms.

Positive spaces are the actual forms.

Hard and soft edges

The edges used to paint the steps convey firmness because of their straight, hard lines. The edges used to paint the flowers and leaves of the bougainvillea bush are softer and uneven, suggesting their real texture.

Before you begin, read the entire project through so you know what's going to happen in each stage.

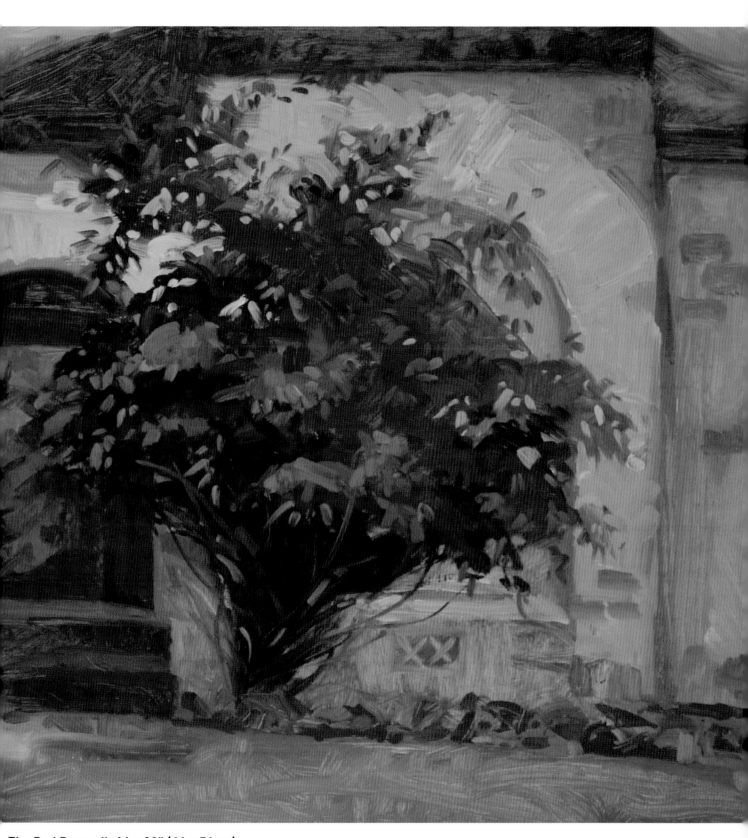

The Red Door, oil, 16 x 20" (41 x 51cm)

The materials you'll need for this project

Support
Artist's quality canvas board

Brushes
Nos. 2, 4 and 6 filberts
No. 8 round

Other Materials
Paint thinner
Scraper
Palette Knife

Artist's Quality Oils

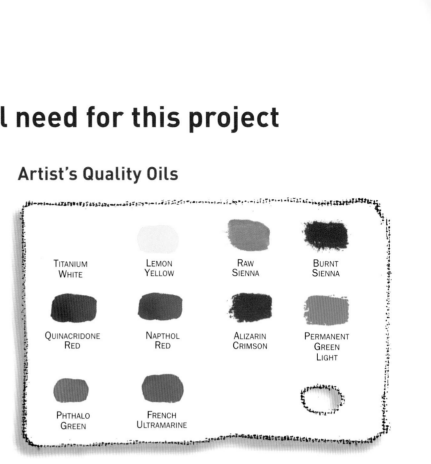

TITANIUM WHITE LEMON YELLOW RAW SIENNA BURNT SIENNA

QUINACRIDONE RED NAPTHOL RED ALIZARIN CRIMSON PERMANENT GREEN LIGHT

PHTHALO GREEN FRENCH ULTRAMARINE

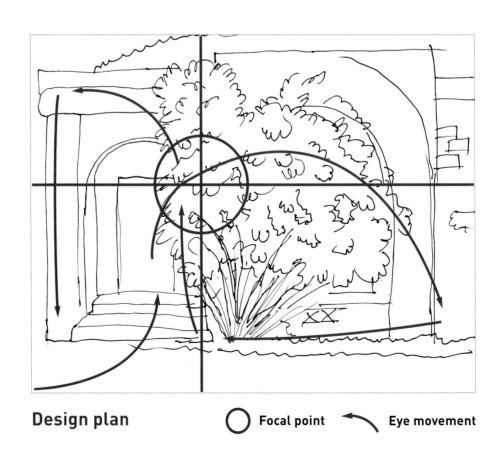

Design plan ◯ **Focal point** ↖ **Eye movement**

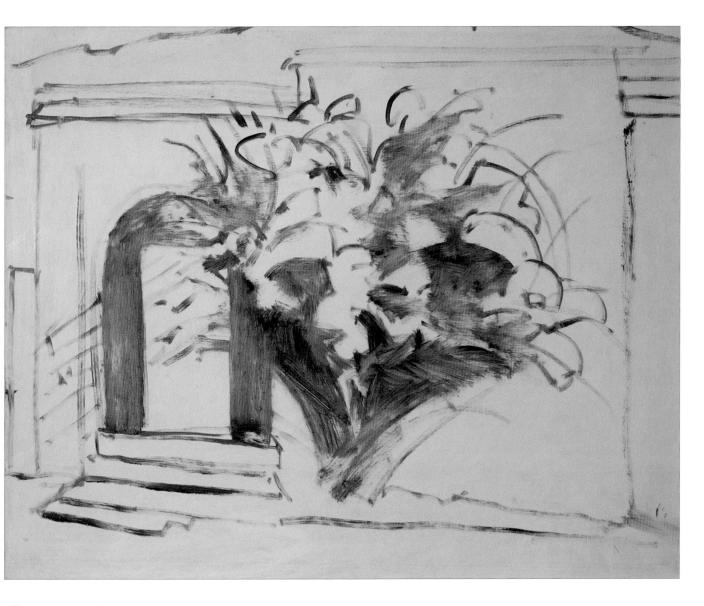

Step 1

Draw the outline and lay in simple washes

- Mix a thin wash of Burnt Sienna and thinner, then using a dry No. 2 filbert lightly draw the outline onto canvas. Extend some of the bush shadows across the door in a diagonal direction.

- Using a No. 4 filbert and the same color lay in a transparent wash underneath the bougainvillea bush.

- Block in the door casing using French Ultramarine and Burnt Sienna. Create the shadow lines caused by the branches on the door and building.

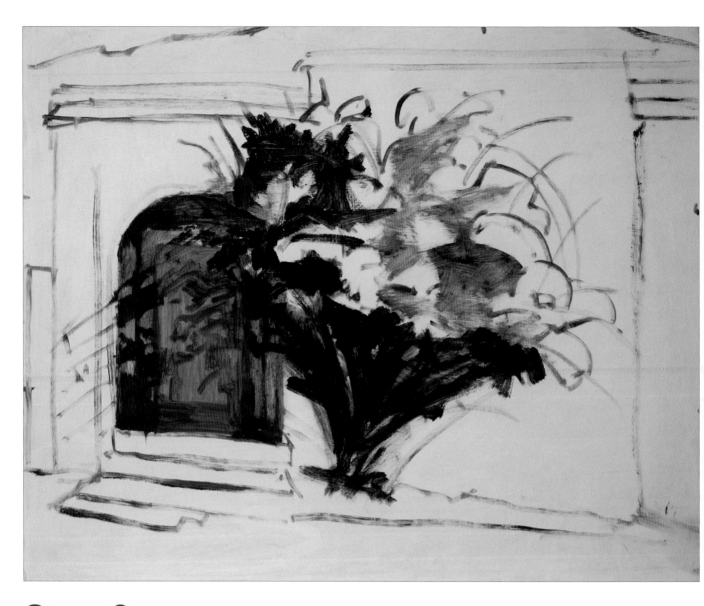

Step 2

Paint the red door and shadows

- Lay in the door using a thin wash of Napthol Red and a No. 4 filbert so that the white value of the support shows through, suggesting that sunlight is shining on it. Reserve the warmer Napthol Red for the door and bricks. Use the cooler Alizarin Crimson and Phthalo Red Rose for the flowers.

- Add the shadows in the door casing using a mix of Permanent Green Light, French Ultramarine and a little of Napthol Red.

- Lay in the lower portion of the bush with dark Burnt Sienna, extending some of the branches toward the door. Keeping the darks close together will help anchor them and keep your painting from becoming spotty.

ALIZARIN CRIMSON

NAPTHOL RED

Reds mixed with Titanium White

QUINACRIDONE RED

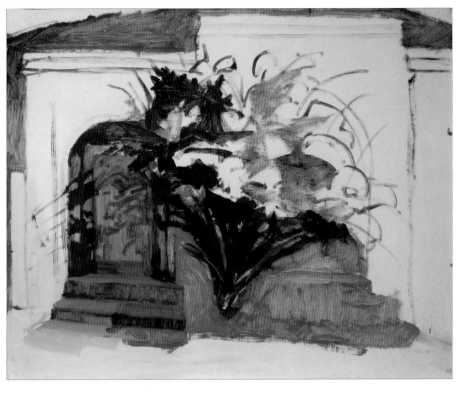

Step 3

Lay in basic elements

- Using a No. 4 filbert and a mix of Raw Sienna and Burnt Sienna to create a different red than that of the door, thinly lay in the steps. Use a harder edge here to suggest a firmer surface.

- Use a touch of Burnt Sienna, Phthalo Green and French Ultramarine for the vertical portion of the steps. Paint the top step using a mix of Titanium White and a touch of French Ultramarine to reflect the sky.

- Paint in the distant hill and the ground under the bush using some palette gray.

- Using French Ultramarine, paint the left side of the house.

- Lay in the shadowed wall area behind the bush using Raw Sienna and palette gray.

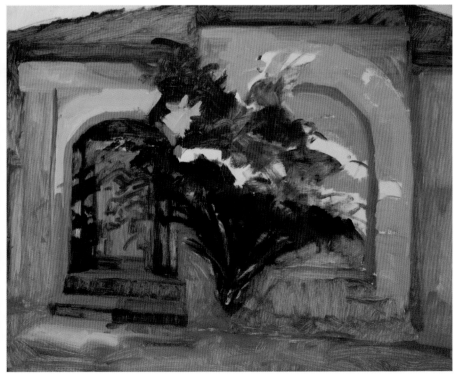

Step 4

Mass in the entire canvas

- Using a No. 6 filbert, lay in the building using mixes of palette gray, Raw Sienna and Burnt Sienna.

- Using a No. 4 filbert, lay in the flat roofline with Burnt Sienna.

- Using a blue-violet mix, accent the archways. Paint the prominent right edge of the house with red-violet.

- Paint the entire ground area with palette gray and Raw Sienna.

- Use a dark pink mix of Alizarin Crimson and Phthalo Red Rose to establish some flowers. Develop the bush with a mix of Permanent Green Light and a little Lemon Yellow, then place dark masses of Burnt Sienna.

- Paint the sky area using a mix of Titanium White, French Ultramarine and a touch of Raw Sienna.

- Using a No. 6 filbert, paint the building using various mixes of Raw Sienna, Titanium White, Napthol Red and Burnt Sienna. Keep some areas transparent and some opaque.

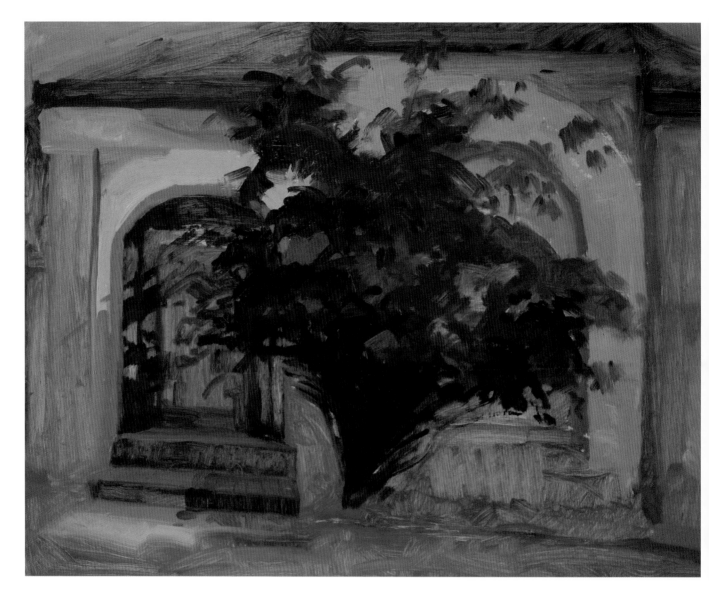

Step 5

Develop the bougainvillea bush

- Using a No. 8 round for a quick delivery of more pigment, develop the bush with a dark green mix. Mass in the flowers using Alizarin Crimson and Phthalo Red Rose, covering all white canvas areas near the bush. Overlap some of the reds and greens to keep the color from separating the shapes.

- Make the sky bluer.

- Using a mix of Burnt Sienna and Raw Sienna, develop the distant hill.

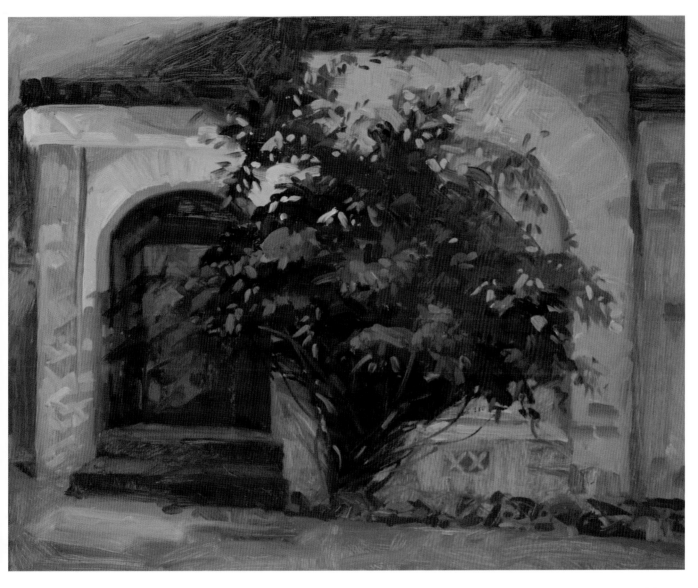

Step 6

Add detail to finish

- Think about the growth pattern of the bougainvillea and start with the darker shadow areas up. Using a No. 2 filbert for detail define the shape of the bush, painting individual leaves in different thicker greens and individual blooms in varying pinks. To act as the wall's appearance between the branches use a palette knife to apply a thicker mix of Raw Sienna and Titanium White. Ensure that the bush doesn't grow out of proportion in relation to the wall and door.

- Using a No. 4 filbert, paint individual bricks on the archways and on the front of the house, adding lighter, richer colors to help define the detail.

- Tone down the shadows inside the door casing by applying a mix of Lemon Yellow, Titanium White and Napthol Red.

- Accent with a mix of Titanium White and Raw Sienna above the door and below the roof.

The tonal values in this painting

PROJECT 4 CARSON VALLEY SUMMER

Creating the illusion of depth

This project will show you how to use scale and value contrast to create the illusion of depth.

The challenges

All landscape paintings have geographical dynamics that we use to describe the location of elements in the scene. These dynamics known as a foreground, midground and background can be established by effectively using scale and value contrast. In addition to gauging the relationship between colors, you're also challenged to keep large areas simple by not overworking them.

What you'll learn
- How to create different textural surfaces
- How shapes relate to one another in terms of space and scale

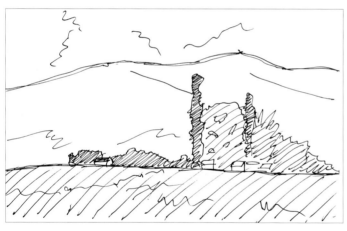

Background

——————

Midground

——————

Foreground

Foreground, Midground and Background

In order to portray a realistic three-dimensional space you need to effectively convey a foreground, midground and background. The element of the scene that is closest to you is the foreground. The background is the furthest away, and the midground sits between the foreground and background. Using the correct value contrasts and proportion of elements in relation to these three spaces is essential to create depth within a scene. For instance, the smaller size of the tree line in the midground compared to the larger size of the grass in the foreground tells us that the tree line is quite a distance away, but not as far as the mountains. The values of the three sections contrast nicely against each other to reflect the dimension of the entire scene.

DEFINITIONS

Scrub in paint by thinly applying it with a stiff brush for a translucent, textured effect.

Scale refers to the proportion of items in relation to each other in a scene.

Before you begin, read the entire project through so you know what's going to happen in each stage.

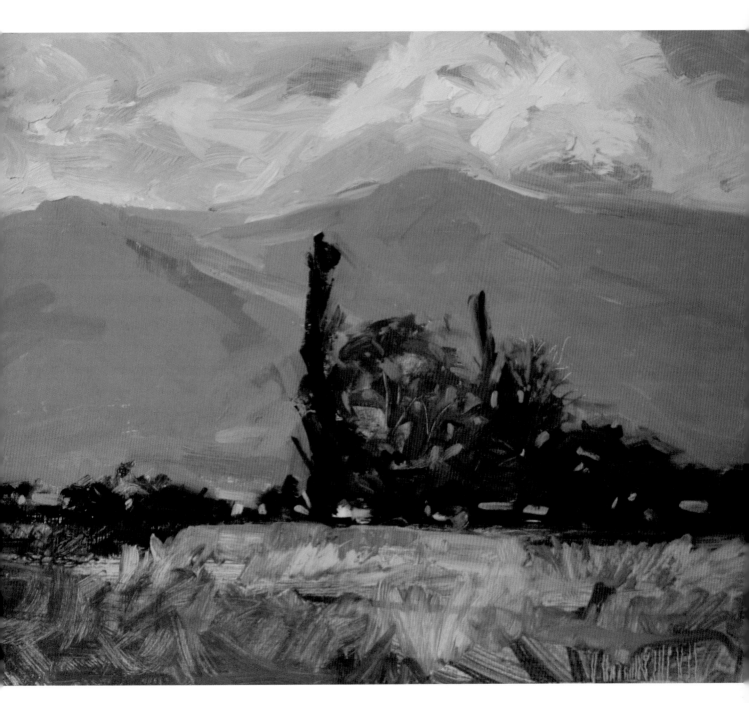

Carson Valley Summer, oil, 15 x 25" (38 x 64cm)

The materials you'll need for this project

Support
Artist's quality canvas board

Brushes
Nos. 2, 4 and 8 filberts

Other Materials
Paint thinner
Scraper
Palette knife

Artist's Quality Oils

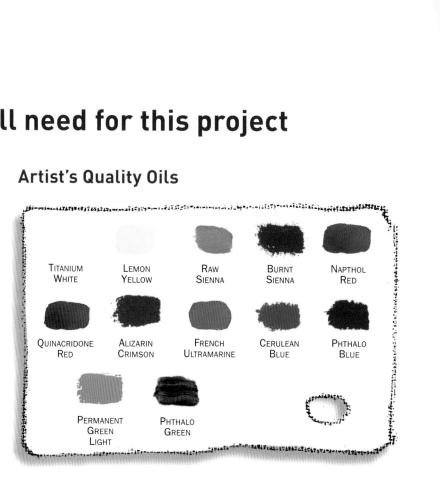

TITANIUM WHITE | LEMON YELLOW | RAW SIENNA | BURNT SIENNA | NAPTHOL RED

QUINACRIDONE RED | ALIZARIN CRIMSON | FRENCH ULTRAMARINE | CERULEAN BLUE | PHTHALO BLUE

PERMANENT GREEN LIGHT | PHTHALO GREEN

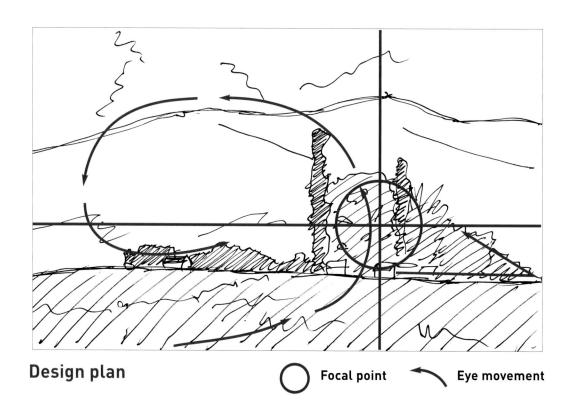

Design plan

◯ **Focal point** ⬅ **Eye movement**

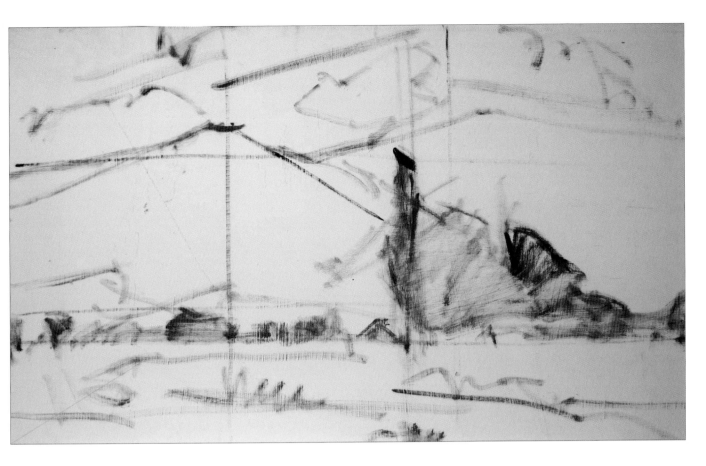

Step 1

Make your outline drawing

- Mix a thin wash of Burnt Sienna and thinner, then using a dry No. 2 filbert lightly draw this outline onto canvas.

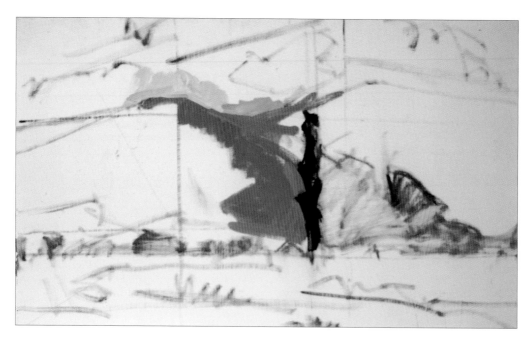

Step 2

Establish
the first values

- Taking care not to get it too dark, begin to loosely lay in the mountain using a blue violet mix of French Ultramarine, Phthalo Red Rose and enough Titanium White to create atmosphere. You'll need a lot of paint on your palette so that you can mix a large amount for the mountain.

- Block in the tallest tree using a mix of Phthalo Green, French Ultramarine and Alizarin Crimson, keeping it transparent.

- Establish the sky using a mix of Raw Sienna, Lemon Yellow and a touch of Titanium White.

PHTHALO GREEN

FRENCH ULTRAMARINE

ALIZARIN CRIMSON

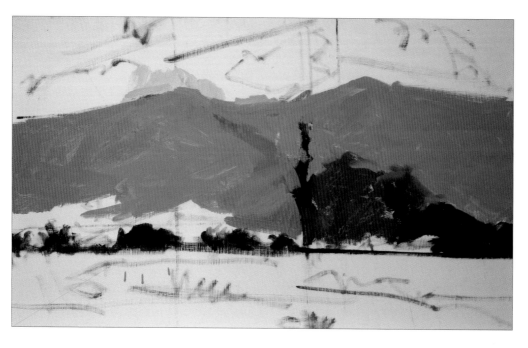

Step 3

Block in the
major color area

- Using a No. 8 filbert, loosely block in the rest of the mountain with the same violet mix, adding a little Phthalo Red Rose to the left and a touch of Lemon Yellow to the right.

- Roughly lay in the tree line under the mountains using a No. 4 filbert and varying green mixes made from Permanent Green Light and Lemon Yellow. Allow some of the underpainting to show through to keep the darks from becoming too heavy and dense.

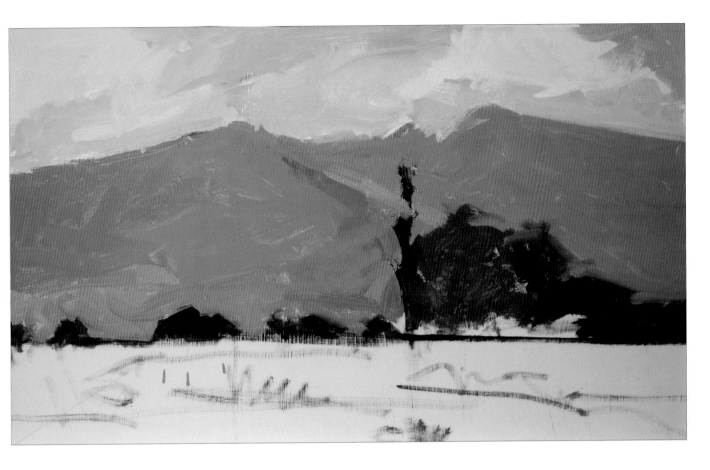

Step 4

Establish the sky to mountain relationship

- Lightly lay in the sky to establish the pattern of sky versus clouds. Use mostly Titanium White and Raw Sienna with touches of yellow in the lighter areas and Napthol Red in the shadows. Create the blue of the sky with French Ultramarine near the top, gaining yellow to become Cerulean Blue as it nears the mountain. Be sure the blues of the sky and mountain are different.

- Create the light on the mountain using a mix of Napthol Red and Raw Sienna, keeping them almost the same value as the mountain so that they stay anchored to one another.

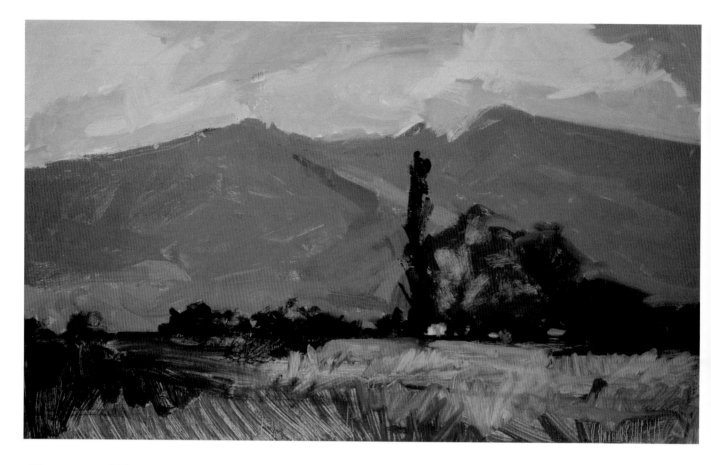

Step 5

Lay in the foreground and develop the midground

- Using a No. 8 filbert, scrub in the entire foreground with a mix of Phthalo Green, Permanent Green Light and some palette gray. To create contrast and variation keep the foreground transparent with thin and loose brushstrokes, allowing the board to shine through.

- Using a palette knife and a dark mix of Alizarin Crimson and Phthalo Green, lay in the tallest tree with upward strokes.

- Using a No. 2 filbert, lift out some lights in the largest tree mass.

- Lay in a suggestion of buildings, keeping each to a single stroke with a loaded brush of clean color. Keep some edges sharp and lose others in the shadows.

NOTE

Don't use too many variations in value in each of the foreground, midground or background areas. The darks belong to the dark areas, and the lighter values belong to the lighter areas.

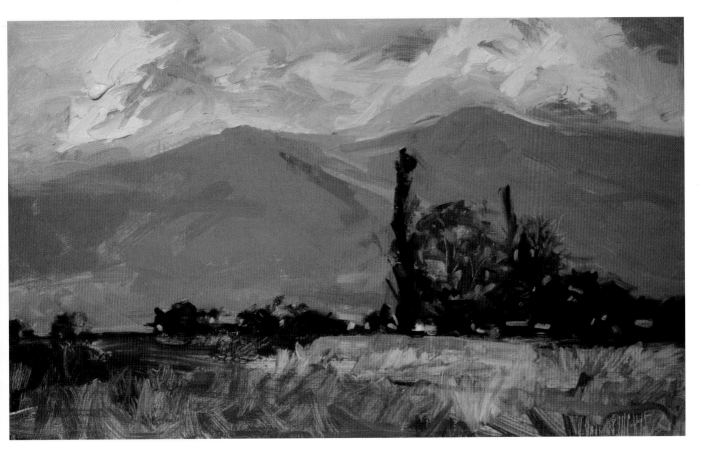

Step 6

Define with detail and movement

- Accent the dark tree line and buildings using a No. 2 brush and a mix of Napthol Red and Raw Sienna.

- Using a palette knife and a brush, texture the clouds with Titanium White and touches of yellow to create movement. The sky/mountain line will create interest. Soften a few edges.

- Create movement in the foreground grass with additional loose brushwork and the Napthol Red and Raw Sienna mix. Go with what you know of clouds, trees and grass blowing in the wind.

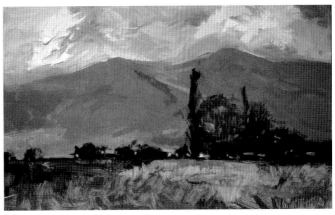

The tonal values in this painting

NOTE
If you overwork an area, scrape it off with your palette knife and start over.

PROJECT 5 WINDSWEPT

Working with moving objects

This project will show you how to suggest movement and correctly interpret color.

The challenges

Like time, clouds wait for no one! They are constantly moving. While you may be painting clouds from a book, an understanding of their movement is necessary to effectively portray them when painting outside. Understanding their three-dimensional structure is also important, and effective use of color is essential to convey this dynamic. While most of us have preconceived notions of what clouds should look like, it's important not to judge shapes or colors until you actually observe them en plein air.

What you'll learn

- How to correctly interpret color
- How to suggest structure and movement of clouds
- How to add colors to original color piles to give variety, yet keep values consistent

How to paint clouds

If you really want to learn to paint skies, then step outside to study the clouds. When you're working outside, sketch their major mass and the diagonals in their movement. As they change hold onto your original drawing, unless the clouds create a better design. Look for the top, side and bottom of the clouds, using three values to portray that structure. While it may be tempting, don't make up their color. You have no idea what color a cloud or the sky is at a particular time until you view it. Instead, compare their color temperatures to find the warm and cool qualities, then ask yourself, "Is this area more red, yellow, blue or green?"

Before you begin, read the entire project through so you know what's going to happen in each stage.

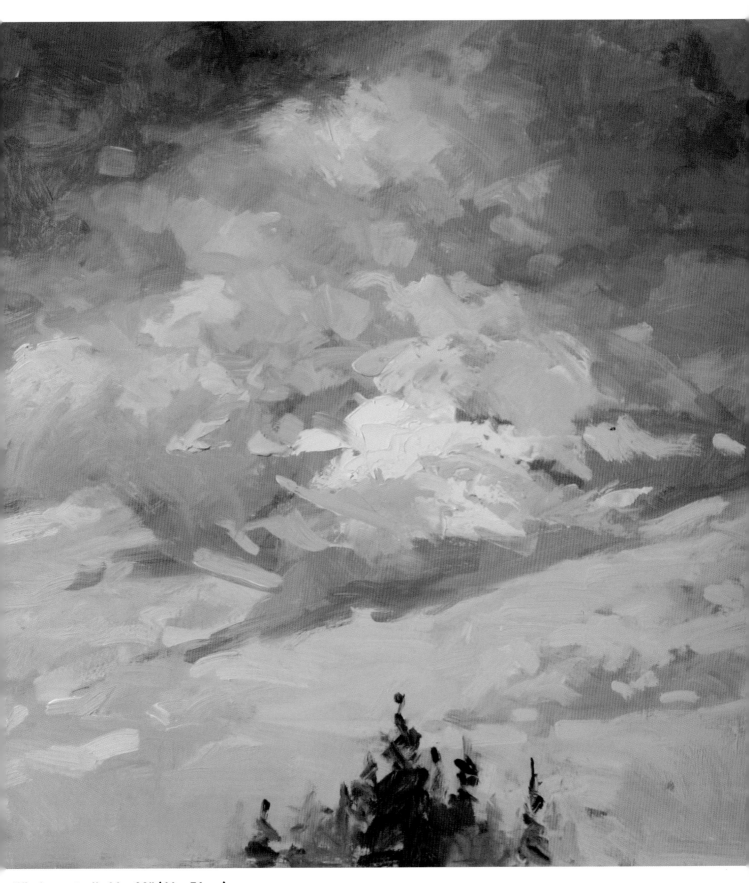

Windswept, oil, 16 x 20" (41 x 51cm)

The materials you'll need for this project

Support
Artist's quality canvas board

Brushes
Nos. 2, 4 and 8 filberts

Other Materials
Paint thinner
Scraper
Palette knife
Paper towels

Artist's Quality Oils

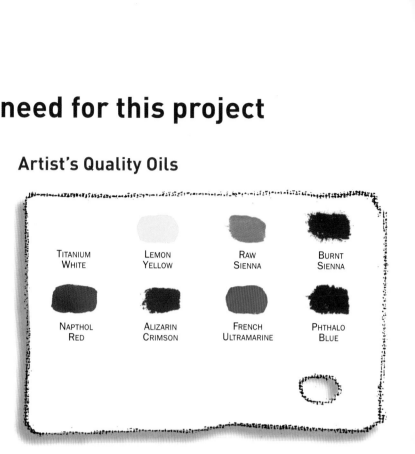

Titanium White	Lemon Yellow	Raw Sienna	Burnt Sienna
Napthol Red	Alizarin Crimson	French Ultramarine	Phthalo Blue

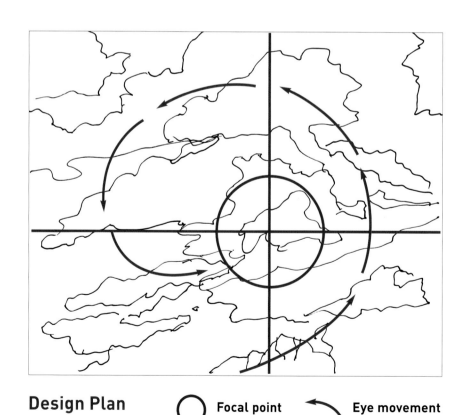

Design Plan ◯ **Focal point** ↖ **Eye movement**

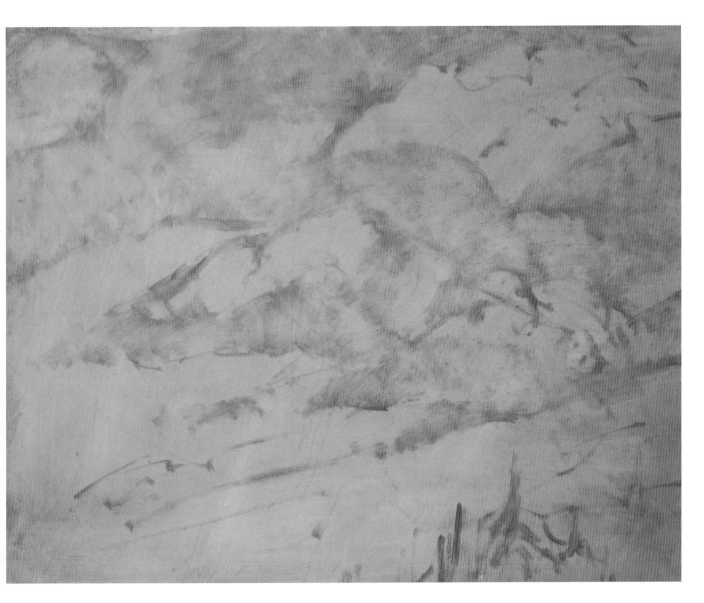

Step 1

Tone your support

• Tone your support using a mix of Burnt Sienna and French Ultramarine. Let dry.

Step 2

Make the outline and basic shapes

• Mix a thin wash of Burnt Sienna and thinner, then using a dry No. 2 filbert lightly draw this outline onto canvas.

• Create the soft cloud appearance by using a paper towel to rub the pigment into the support, sculpting the shapes until they appear soft and wispy. Diagonals are necessary to create movement in any painting. In this project we are composing the clouds and the sky surrounding them on a strong uplift from left to right.

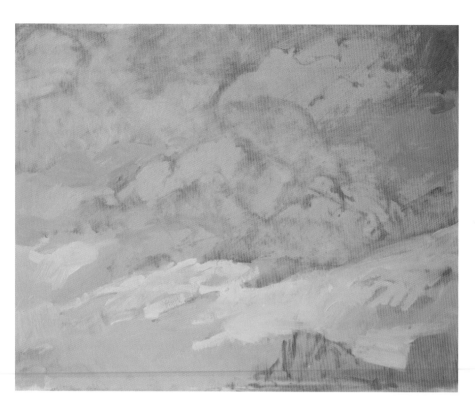

Step 3

Establish the sky values

- Starting in the upper right corner, use a No. 4 filbert and a mix of French Ultramarine and a little Titanium White to lay in the sky. Add Phthalo Blue to the mix as you work down the panel for a graduated effect. Remember that these first values will determine the overall value of the final result.

NOTE
The lighter pink area is the toned support that hasn't been painted on yet. Use the negative painting concept to preserve some of these areas as part of the finished painting.

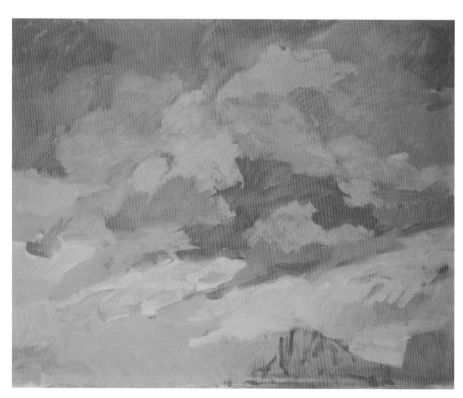

Step 4

Block in mid-value shadows

- Using a No. 8 filbert and different mid-value grays created from mixes of French Ultramarine, Alizarin Crimson and Titanium White, lay in the shadows created by the clouds. If the color is too pure, add a touch of Raw Sienna.

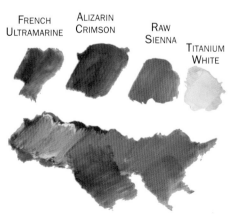

FRENCH ULTRAMARINE ALIZARIN CRIMSON RAW SIENNA TITANIUM WHITE

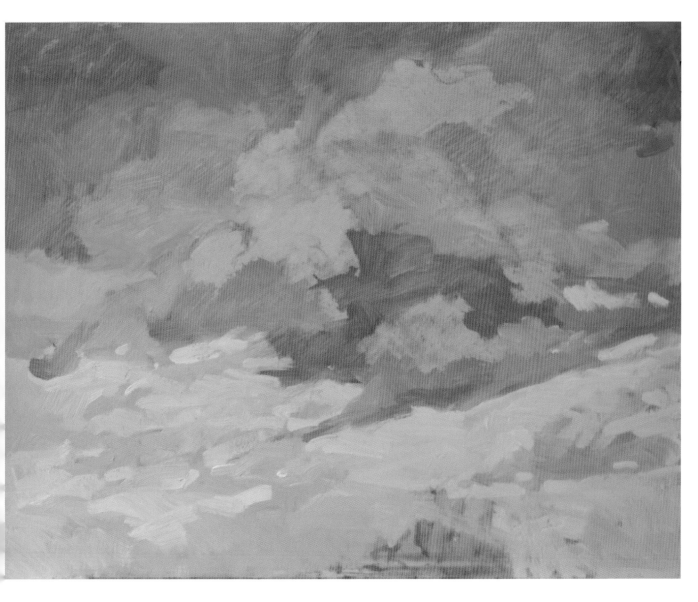

Step 5

Lay in the horizon clouds

- Lay in the clouds closer to the horizon using a mix of Titanium White, Alizarin Crimson and French Ultramarine. These clouds will be lighter, with less contrast and color than those in the foreground. Their values should be close to the sky value in that area.
- Work a lighter mix of Phthalo Blue and Lemon Yellow into the areas of sky behind the large clouds, allowing some of the clouds to pop. Keep this limited or it will lessen the effect.
- Start cutting in some sky holes to make the clouds appear more fluid.

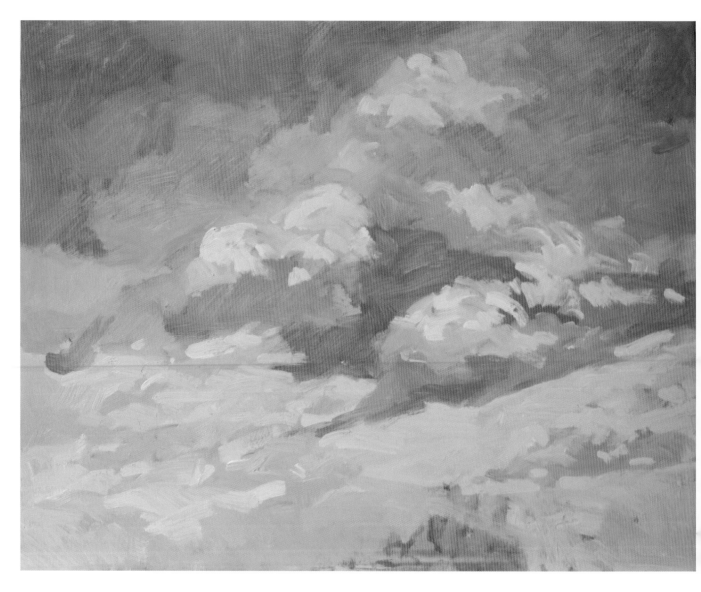

Step 6

Introduce the lighter cloud forms

- Mix a darker shade of white and work the movement of the clouds. Use different mixes of palette grey, Titanium White and touches of blue or red for the clouds. None of the clouds are pure white. Knowing when to hold back on color is as important as using color.

- Using your existing mixes, add subtle color to the clouds. If they tend to be on the boring side without variety, then decide which ones to enlarge, which ones to warm up and which ones to redesign. Turning your panel upside down will allow you to see the design better so that you can make any necessary corrections.

> **NOTE**
> In order to make one color darker sometimes it's easier and more exciting to make the color next to it lighter and cleaner.

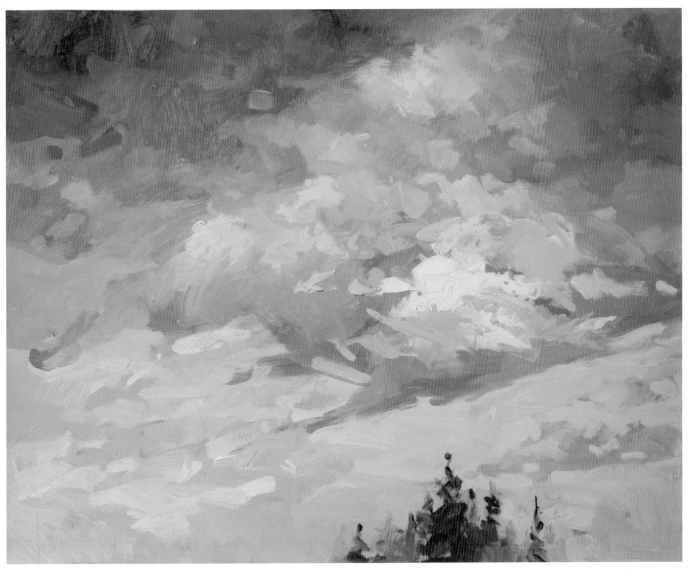

Step 7

Add the finishing touches

- Warm or cool some of the existing mixes by adding Raw Sienna, French Ultramarine or Alizarin Crimson, accenting some of the clouds with the same gradual effect of darker to lighter from top to bottom. Keep shadowed areas quiet by having their values close to their surroundings.

- Cut in more sky holes to help define the cloud shape or to break up a solid form.

- Using a palette knife, apply dark shades of white to the focal point clouds to suggest their nearness.

- Using delicate strokes with a No. 2 filbert, paint the tree forms last with a mix of French Ultramarine, Alizarin Crimson and Phthalo Green, adding the sky mix as the trees recede. The trees give a sense of scale to the sky and create a third dark which forms a triangle and helps direct the eye.

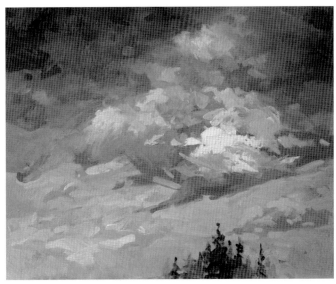

The tonal values in this painting

PROJECT 6 SANTA FE SUNSET

Making skies that glow

This project will show you how to use values and edges to portray the luminosity of the sky and solidity of the earth.

The challenges

When painting a sunset it's important to keep the majority of the painting simple, yet you also have to establish a value relationship between the sky and land so that the sunset is filled with beautiful light. This translucence is achieved by effective use of grays and deep jewel tones in the earth areas. While you can have many colors in one ground area, your challenge is to keep them in the same value family for a powerful statement. Mixing color and laying it down in the right place is also important to keep color from being muddy.

What you'll learn

• How to create the effect of luminosity

• How the land mass can support the sky, yet remain jewel-like

• How to mix close values for area, but shift values and intensity for differentiation

• How to mix beautiful grays that create drama and support the sky/earth relationship

Portraying translucent light

Creating translucent light is best done with thin, mid-value pigments, keeping the heavier, darker pigments out of the sky. Painting a sunset requires starting from the lightest, most intense area in order to establish the correct value with the next color you lay down in the background or sky area. While these area values relate to each other, ensure that each ground area (foreground, midground and background) has a different value family. Palette gray mixed with touches of pure pigment such as yellow, rose or blue also support translucent light, making it appear to be brighter.

Before you begin, read the entire project through so you know what's going to happen in each stage.

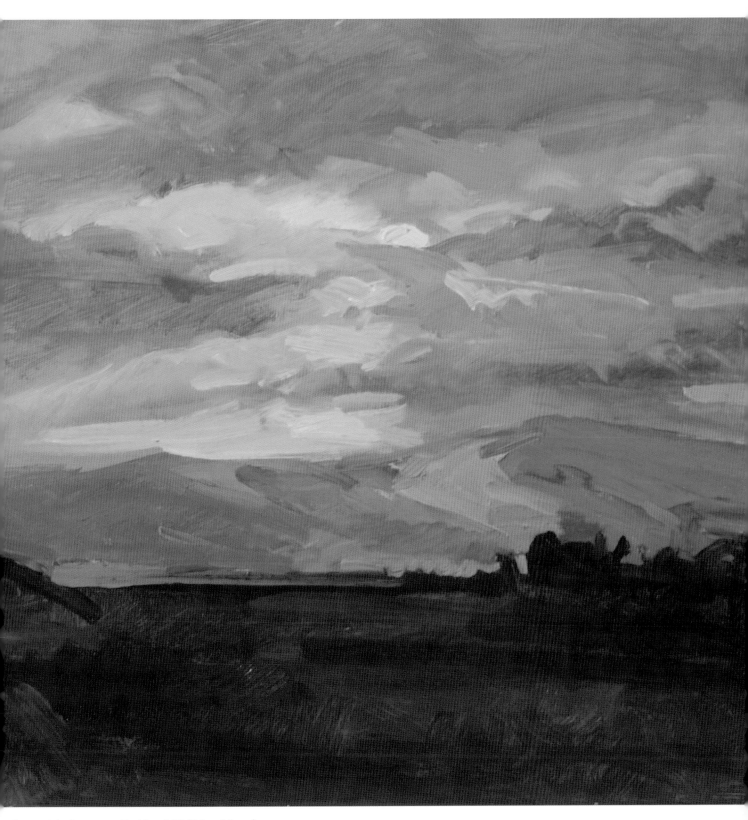

Santa Fe Sunset, oil, 12 x 16" (30 x 41cm)

The materials you'll need for this project

Support
Artist's quality canvas board

Brushes
Nos. 2, 4, 6 and 8 filberts

Other Materials
Paint thinner
Scraper

Artist's Quality Oils

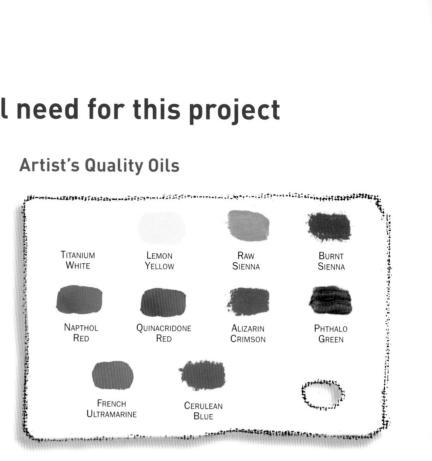

TITANIUM WHITE LEMON YELLOW RAW SIENNA BURNT SIENNA

NAPTHOL RED QUINACRIDONE RED ALIZARIN CRIMSON PHTHALO GREEN

FRENCH ULTRAMARINE CERULEAN BLUE

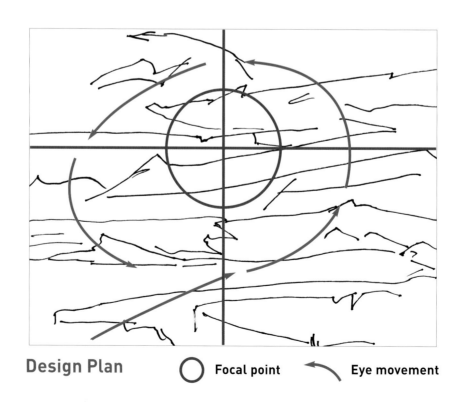

Design Plan ◯ **Focal point** ⟵ **Eye movement**

Step 1

Tone your support

• Tone your support using Burnt Sienna. Let dry.

Step 2

Make the outline

• Mix a thin wash of Burnt Sienna and thinner, then using a dry No. 2 filbert lightly outline the cloud forms and land mass onto canvas. In case any holes show through your painting, the warm wash will hold your painting together if the value is correct.

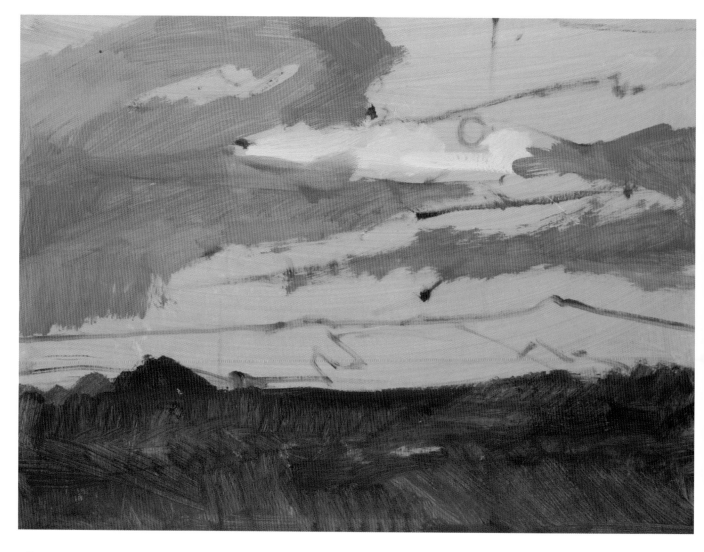

Step 3

Thinly establish the first values

- Block in the violet clouds using a No. 8 filbert and a mix of Alizarin Crimson, French Ultramarine and Raw Sienna, keeping the value in the middle range. Use softer edges in the cloud area versus the harder edges of the mountains and tree line.

- Lay in the light yellow clouds using a mix of Titanium White and Lemon Yellow, so that there will be a nice contrast with the violet clouds, creating luminosity.

- In order for the sky to appear light, it needs to be surrounded with darker, grayer colors. Block in some of the clouds with palette gray mixed with touches of Lemon Yellow, Phthalo Red Rose or blues.

- To give the darks a semi-opaque quality, thinly scrub in the ground area with Phthalo Green, Alizarin Crimson and a touch of French Ultramarine. The dark sky colors will still look translucent when compared to land mass.

ALIZARIN CRIMSON

PHTHALO GREEN

NOTE

Use separate brushes for the sky and land so the colors aren't contaminated.

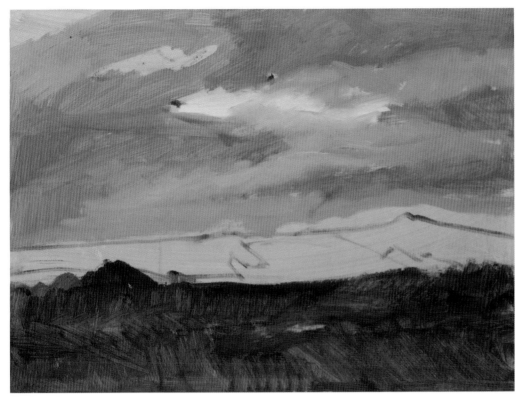

Step 4

Block in warm sky colors

- Using a No. 6 filbert and a thin mix of Burnt Sienna, Lemon Yellow and a touch of Titanium White, block in the warmer sky colors, keeping the color intense in the upper right corner. Use less Burnt Sienna with a little more Titanium White as you near the mountains.

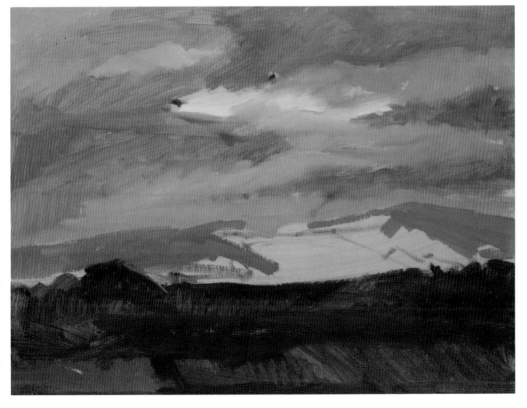

Step 5

Establish the blues and violets

- Lay in the sky with French Ultramarine at the top and Cerulean Blue lower down. Be sure to leave areas where the blues appear unpainted or your colors will appear muddy.

- Create the shadows on the mountain using Alizarin Crimson, French Ultramarine and a touch of Titanium White, keeping the color dark, but lighter than the foreground to create distance between the two ground areas.

- Thinly apply more Alizarin Crimson on the left side shadows and more French Ultramarine on the right, creating interest as the eye travels across the painting.

- Start working on the ground area, but be sure that the values remain close, but separate from the sky values.

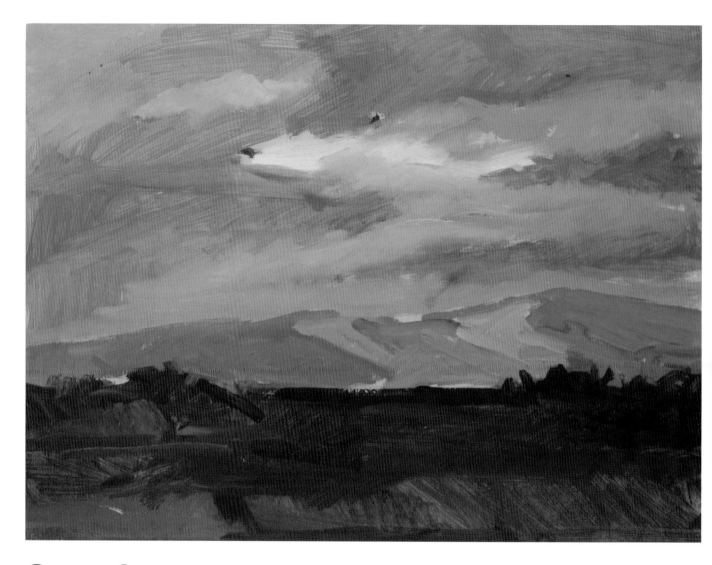

Step 6

Introduce sunlight to the mountain

- Now painting more opaquely, lay down a mix of Napthol Red, Lemon Yellow or Raw Sienna and a touch of Titanium White to the sunlit area of the mountain. Adding Titanium White makes a color more opaque, and thus more earthy compared to the transparent sky. Lay it down in one pass. Be deliberate.

- Establish the trees along the line between the foreground and midground.

- Continue to add interest to the foreground.

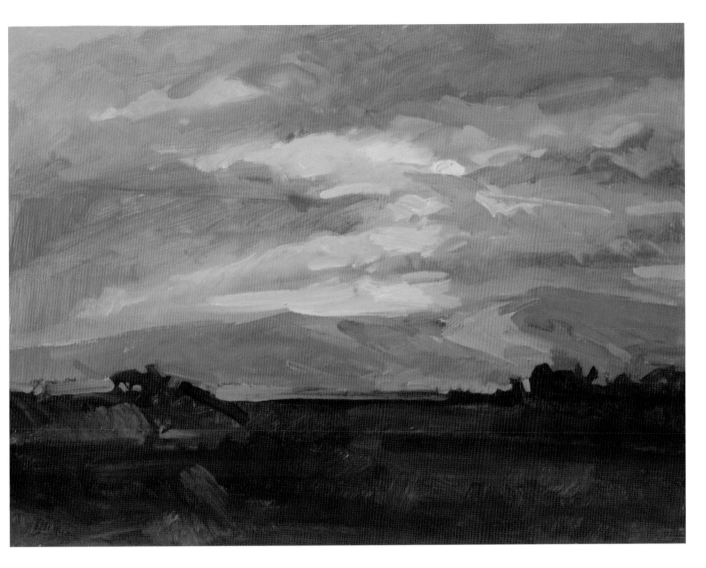

Step 7

Finish with edge control

- Using the yellow cloud mix, accent the focal point clouds for contrast. Lay the color down with one pass.

- Using a No. 4 filbert, soften the edges to make them more gentle and soft, yet remember that edges help create differences when areas are really close in color and value.

- Add small touches like clouds broken by sky holes, and play up the foreground area by scrubbing in more Alizarin Crimson and darks.

The tonal values in this painting

Finding the color of white in shadow

This project will show you how to determine the color of white in shadow and the color values within a section.

The challenges

Copying any image from a photo is far easier than seeing a color or value in reality and mixing it because we're often in the same light that we're attempting to paint. Creating the darkness of white in shadow and still having it appear to be white is a challenge that you can master with practice. It's also important that you learn how to lay in each area to a level of completion and leave it alone. For this, a detailed color spot study will help you find the value and temperature of each color, lay it down and move on to the next section.

What you'll learn

• How to find the value of white in shadow

• How to simplify shapes so they act as separate units within their value areas

• How to do a color spot study.

In the sun

Out of the sun

The color of white in shadow

Because it's often difficult to understand the values of your own surroundings, it helps to step outside your environment and see it as an outsider looking in. It's also important that you know where to begin. In this project, beginning with the lightest light of the inner court will act as a gauge for you to find the value of white in shadow. By the time you "walk" out to the white wall from the sunlit inner court you'll understand that all of the shadowed areas should be close in value and muted in color.

Before you begin, read the entire project through so you know what's going to happen in each stage.

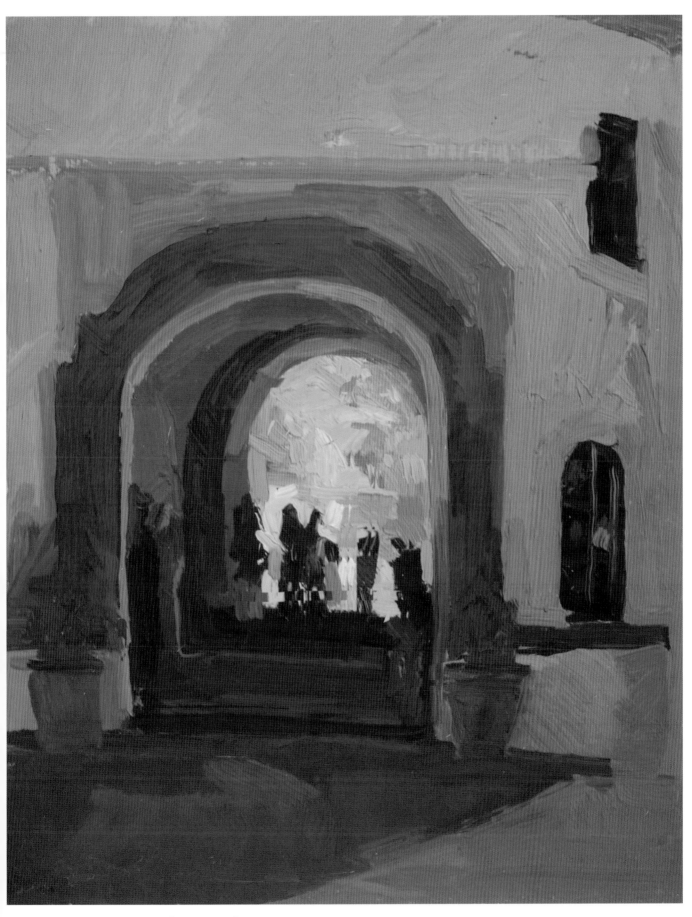

Inner Archway, oil, 10 x 8" (25 x 20cm)

The materials you'll need for this project

Support
Artist's quality canvas board

Brushes
Nos. 2 and 4 filberts

Other Materials
Paint thinner
Scraper

Artist's Quality Oils

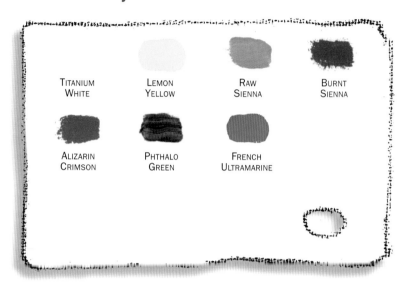

TITANIUM WHITE LEMON YELLOW RAW SIENNA BURNT SIENNA

ALIZARIN CRIMSON PHTHALO GREEN FRENCH ULTRAMARINE

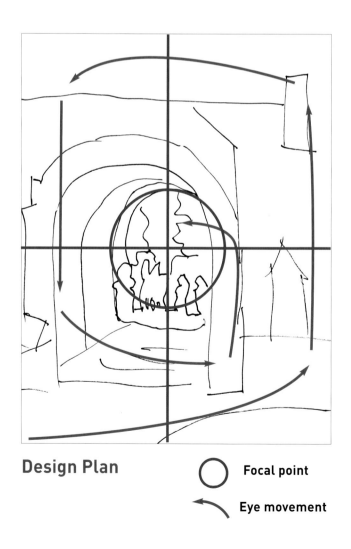

Design Plan

⭕ **Focal point**

↩ **Eye movement**

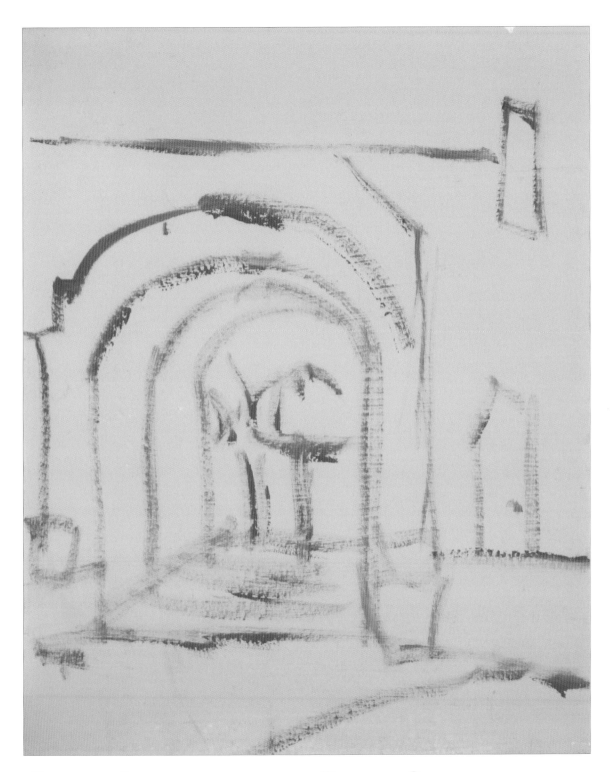

Step 1
Tone your support

- Tone your support using Burnt Sienna. Let dry.

Step 2
Draw the outline

- Mix a thin wash of Burnt Sienna and thinner, then using a dry No. 2 filbert lightly draw the outline onto canvas. Although the center of interest is almost dead center, the design is playing the simplicity of the right side to the complexity of the left side, with the balance of shapes worked out in the one-third principle.

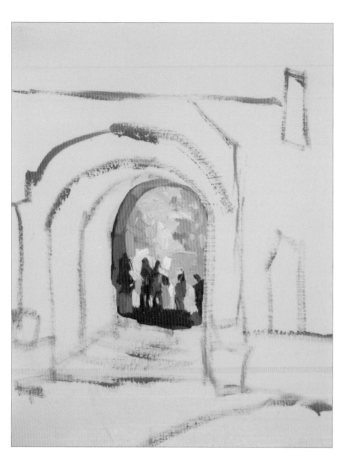

Step 3

Block in focal point shapes

- Lay in the sunlit inner court using mostly Titanium White, adding Phthalo Green, Lemon Yellow and Alizarin Crimson. Leave the area for the figures unpainted.
- Using a mix of all your dark pigments, lay in the dark silhouetted figures.
- Lay in the dark innermost part of the archway. Mix a little Titanium White and Alizarin Crimson for a reflective effect.
- Suggest the trees inside the arch using a mix of Titanium White, Phthalo Green and Alizarin Crimson. Add Lemon Yellow and Titanium White accents to the trees so they pop when later surrounded by rich darks.

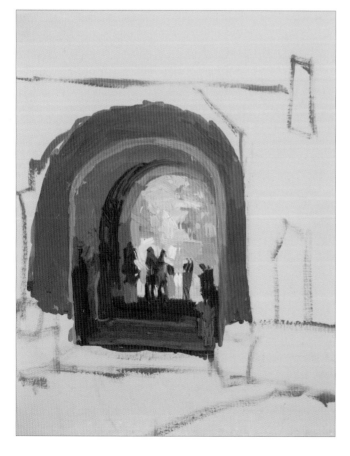

Step 4

Lay in the middle of the archway

- Working outward from the inner court, use a No. 4 filbert and the dark mix on the middle of the archway where the sun doesn't hit. Keep the structure correct and the ground lines horizontal.
- Keeping the values close, add a touch of Titanium White to the dark mix as you develop the archway to suggest the light that is creeping in. The darkness of the archway provides contrast to the light colors of the inner court.

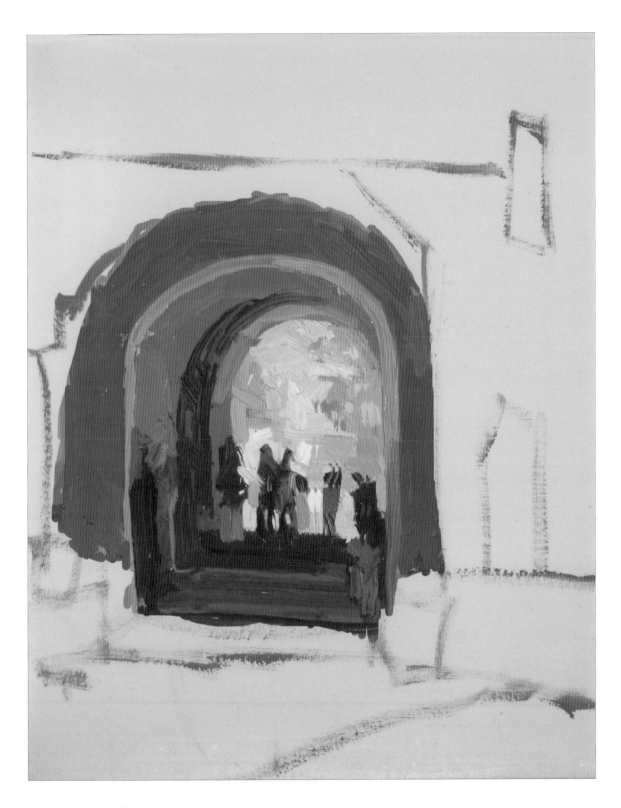

Step 5

Complete the archway

- Finish the archway using the dark mix with a touch of Titanium White and Phthalo Green for the floor. Accent the shadowed side of the archway with darks.
- Paint the inner portion of the outside trim, lightening up the dark mix with a touch of Titanium White. Lay in the portion above that with a mix of French Ultramarine, your choice of color and enough Titanium White to open up the color. Ask yourself if the blue has more red, green or yellow in it, then add it but keep the values close.

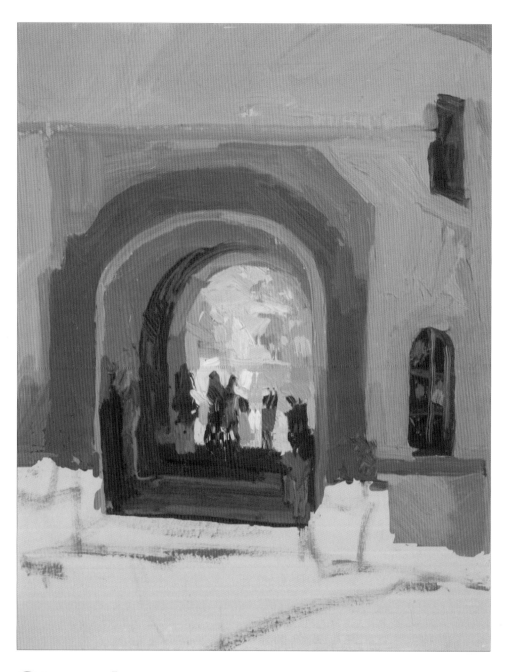

Step 6

Lay in the building

- Using a mix of Titanium White, French Ultramarine, Raw Sienna and Alizarin Crimson to create the shadowed white color, use a No. 4 filbert to lay in the building. Be sure to make a large mix so that you can add touches of color to create the nuances without having to worry about changing the values.

- Anchor the dark blue to the upper wall using a mid-value Phthalo Green and a touch of Raw Sienna in your building mix. Use this mix with a touch of Raw Sienna for the wall by the windows.

- Add the windows using a touch of French Ultramarine, Alizarin Crimson and Phthalo Green.

- Using a dark red mix of Alizarin Crimson, French Ultramarine and a little gray, create the effects near the bottom of the building.

TITANIUM WHITE

RAW SIENNA

NAPTHOL RED

FRENCH ULTRAMARINE

This is the color of white in shadow.

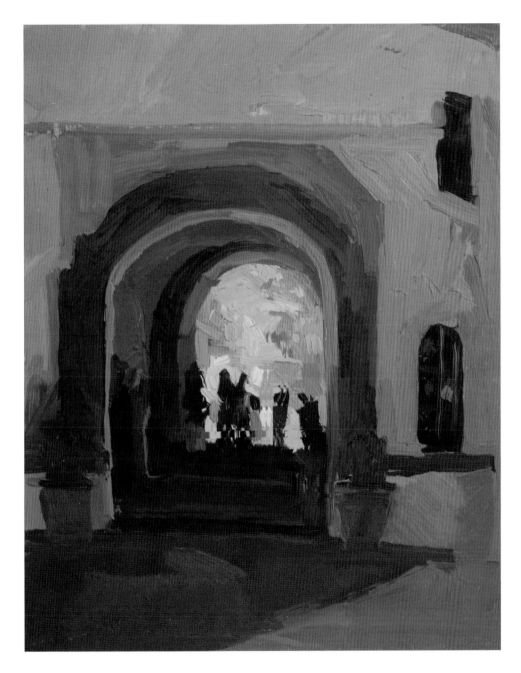

Step 7

Finish with foreground and detail

- Lay in the ground in shadow using a dark red mix of Burnt Sienna, Alizarin Crimson and French Ultramarine. Lighten it with Titanium White and Raw Sienna for the right foreground area. Keep your brushstrokes simple and direct. Mix a color and lay it down.
- Paint the flower pots with the dark red mix, then lay down the rims in one pass with a dark color. Lay in green plants with dark red blooms.

NOTE

The colors on the building are kept from being muddy because they're enhanced by rich jewel tones of the same value.

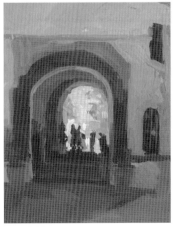

The tonal values in this painting

PROJECT 8 SAND CREEK

Working with water and reflections

This project will show you how to accurately depict water and its reflective qualities.

The challenges

Water can have many different appearances depending on the available light, its movement and the objects it reflects. The challenge is to suggest a fluid surface that anchors in value with the land mass to create a feeling of stability and depth, yet reflects its environment.

What you'll learn

- How to create different textures through simple application of paint
- How to create deep jewel tones without getting dense and heavy
- When to create a smooth surface and when to make it ripple in contrast

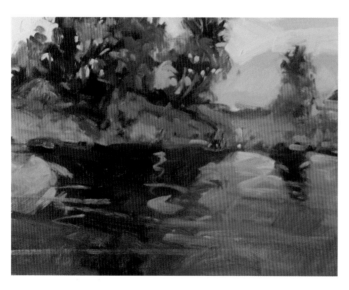

Painting reflections

Many different factors influence water's ability to reflect, including the time of day, the season, the environment and the objects surrounding it. Your point of view with regard to the sun and water also makes a difference. These factors may make water appear to be deep in value like jewel tones or light in value like opals. They may also make the water ripple with movement or sit still like smooth glass. While the water should reflect the clouds and objects around it, the water and the reflections should be close in value. Light colors reflected in water will darken and dark objects will lighten, both leaning toward a middle value.

Before you begin, read the entire project through so you know what's going to happen in each stage.

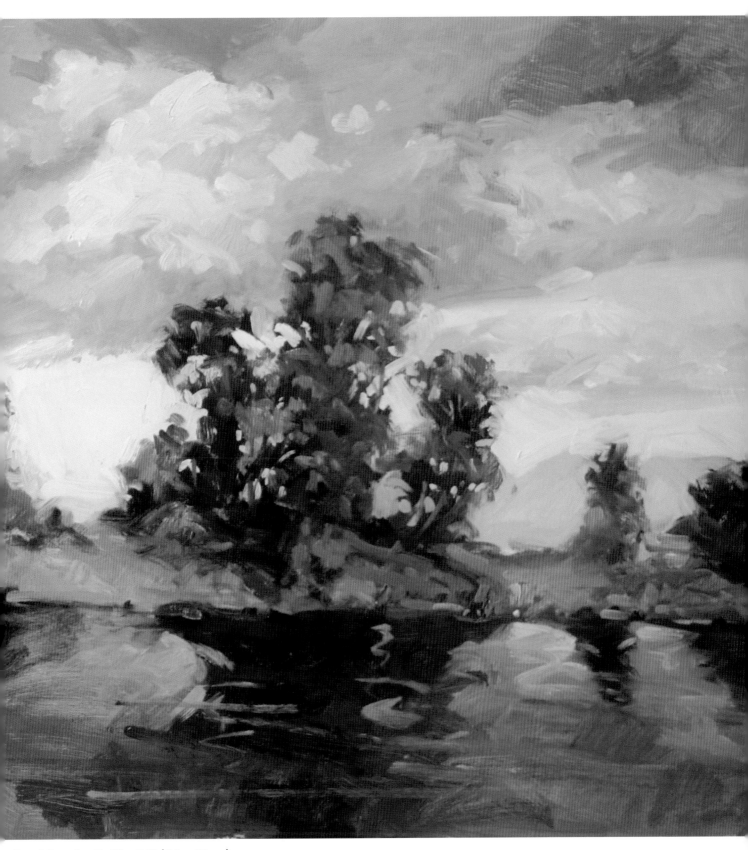

Sand Creek, oil, 18 x 24" (46 x 61cm)

The materials you'll need for this project

Support
Artist's quality canvas board

Brushes
Nos. 4 and 8 filberts
No. 8 round

Other Materials
Paint thinner
Scraper

Artist's Quality Oils

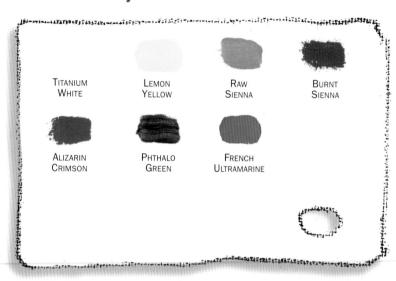

TITANIUM WHITE LEMON YELLOW RAW SIENNA BURNT SIENNA

ALIZARIN CRIMSON PHTHALO GREEN FRENCH ULTRAMARINE

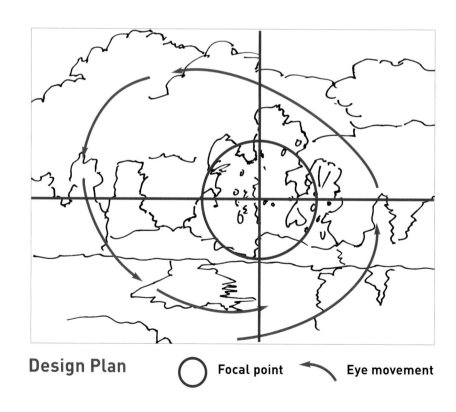

Design Plan ◯ **Focal point** ⌒ **Eye movement**

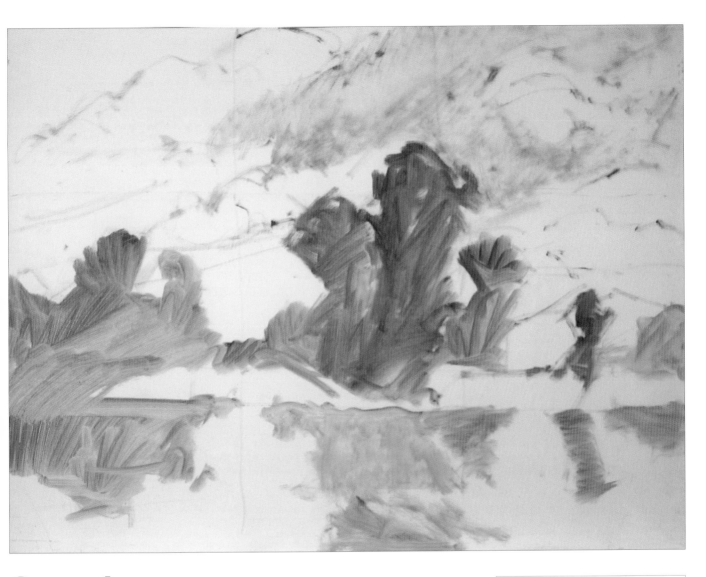

Step 1

Wash in the main shapes

• Mix a thin wash of Burnt Sienna and thinner, then using a dry No. 8 filbert lightly wash the main shapes onto canvas. Be sure to mark the panel into thirds to keep elements from centering.

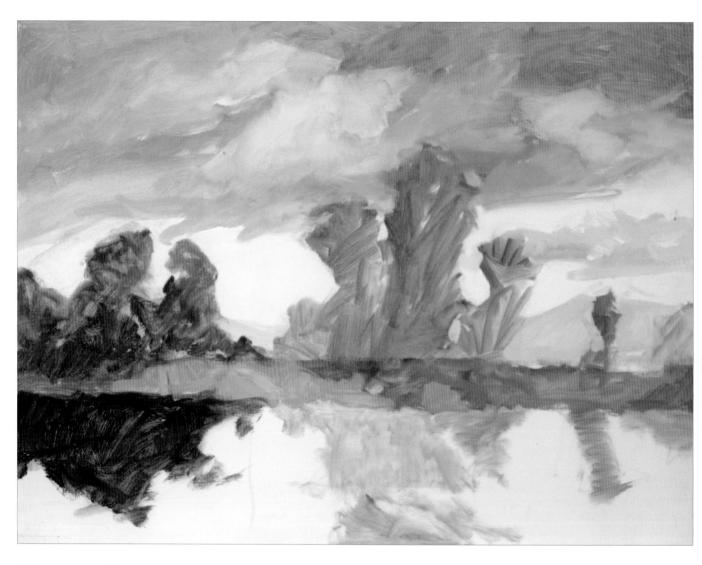

Step 2

Introduce color

- Lay in the upper sky using a No. 8 round and a mix of French Ultramarine and some Titanium White. Block in a mix of Phthalo Green, Lemon Yellow and Titanium White as the sky nears the horizon.

- Create the clouds using a mix of Titanium White and Raw Sienna, making some whiter than others. Use Alizarin Crimson for the rose tone behind the trees, and a mix of French Ultramarine, Alizarin Crimson and Raw Sienna for the dark cloud in the corner.

- Using a No. filbert, block in the distant mountain using French Ultramarine, Alizarin Crimson and Titanium White.

- Lay in the ground using a mix of Titanium White and Raw Sienna. Add the shadowed areas using a touch of Phthalo Green and Raw Sienna. Keep the shadow areas transparent to allow the white of the board to shine through.

- To establish the values, thinly lay in the tree line with Burnt Sienna, Raw Sienna and Phthalo Green. Using slightly thicker paint, establish the reflections using Burnt Sienna, French Ultramarine and a touch of Alizarin Crimson.

TITANIUM WHITE

PHTHALO GREEN

LEMON YELLOW

Lower sky mix

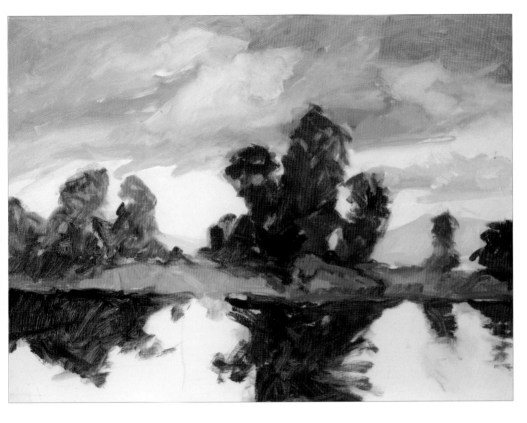

Step 3

Develop the tree line and reflections

- Using a No. 4 filbert, complete the tree line using a thin layer of Burnt Sienna, Raw Sienna and Phthalo Green. Work toward understanding their growth pattern — how they lean, the spaces between their branches and the negative spaces between the branches.

- Finish the reflections using Burnt Sienna, French Ultramarine and a touch of Alizarin Crimson, keeping them transparent and warm. Allow the board to shine through the thin layer of paint.

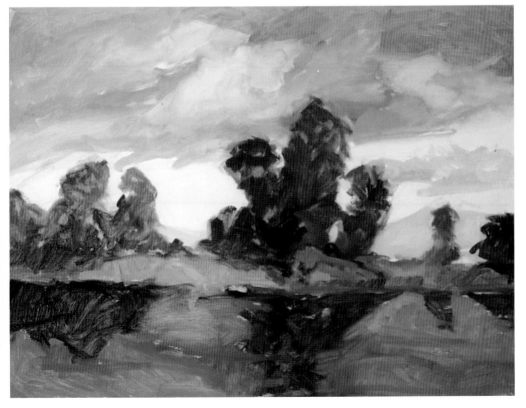

Step 4

Lay in the water

- Using a No. 8 filbert, loosely paint the water using French Ultramarine and Titanium White. Variate the mix colors for a feeling of movement.

- Use dashes of Alizarin Crimson to suggest the reflections of the clouds in the water. Let your paint flow outside the lines, constantly feeling fluid and liquid like the water. The values of the water and the reflections should be very close.

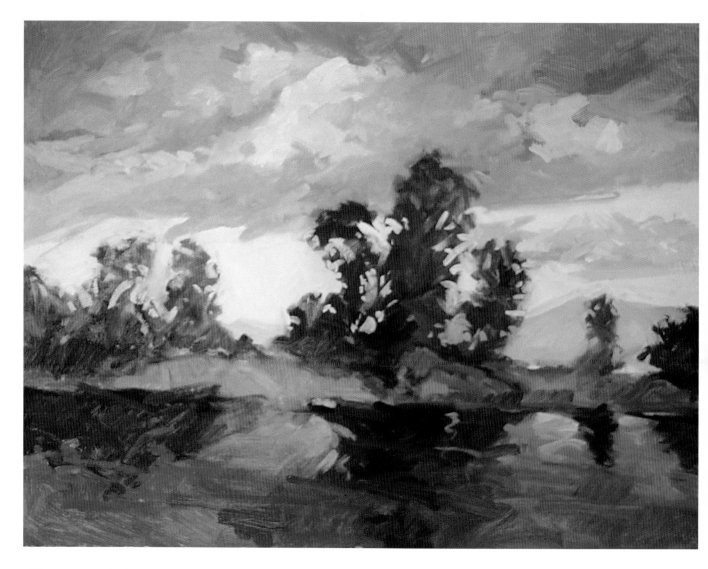

Step 5

Define all elements

- Using a No. 8 filbert, develop the sky by creating sky holes and shifting the temperatures, making areas warmer or cooler. Keep the shadows and lights to their respective value areas.

- Working in loose fluid strokes, define the water by making it look more reflective. Using a No. 4 filbert, add some Phthalo Green to where the water meets the ground. If you work quickly that energy will carry into the energy of the water.

- Add negative spaces between the branches using your lower sky mix. Think of the growth pattern of the trees.

NOTE

For a delicate vertical line, place it on top of paint that has been applied with a horizontal stroke. No paint stroke can compete with the same kind of stroke next to it, so always play opposites.

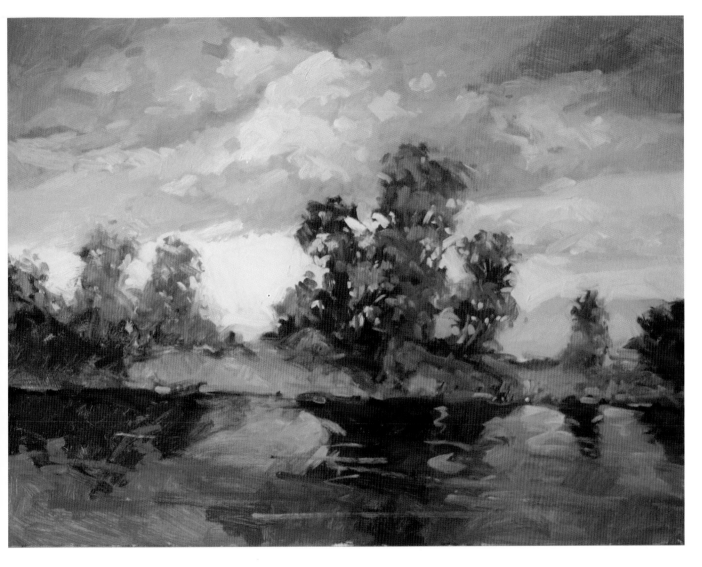

Step 6

Finish with detail

- Using the same colors and mixes, add little gems of color to the clouds, trees, ground and water.
- Brushing over your previous work, lay in boughs of color for the trees using a mix of Phthalo Green, Raw Sienna and a little Titanium White in some areas. Use that mix with Lemon Yellow in other areas.
- Using a brush loaded with transparent lighter colors, drag it across the water for long ripples.

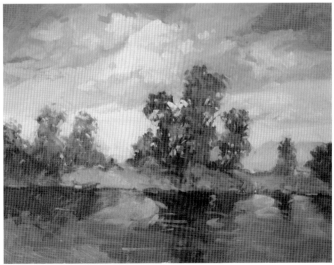

The tonal values in this painting

PROJECT 9 EVENING REPOSE

Portraying evening light in shadow

This project will show you how to suggest evening light in shadow by using close values and simple shapes.

The challenges

Creating the illusion of evening light in shadow involves effective use of colors and close values in the shadow area, as well as the value contrasts that signify the time of day. Identifying values that are relative, but different enough to create interest will further your understanding of the subject. Simplifying shapes will also allow you to create an illusion of evening light in shadow.

What you'll learn

• How to compare close colors and values

• How to simplify shapes and information and still have an effective painting

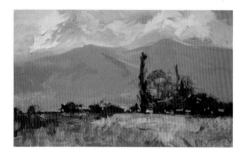

Carson Valley Summer

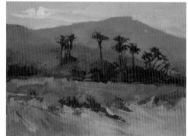

Evening Repose

Compare evening and late afternoon

Why is it that Carson Valley Summer on page 38 and this project have the same mountain color and value, yet are able to convey different times of the day? It's because of the value contrast. Compared to the highly value-contrasted Carson Valley Summer, the midground and foreground of this project are darker and closer in value, suggesting that they're in the shadow of the mountain. The shapes are also simplified in this project because they're harder to see when they're in shadow, compared to the defined shapes of Carson Valley Summer.

Before you begin, read the entire project through so you know what's going to happen in each stage.

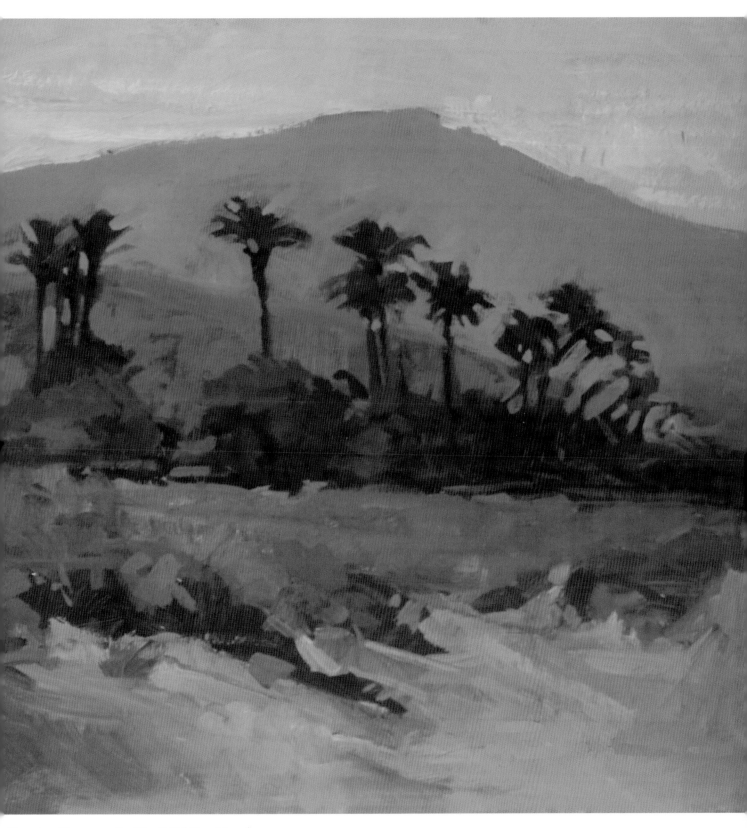

Evening Repose, oil, 18 x 24" (46 x 61cm)

The materials you'll need for this project

Support
Artist's quality canvas board

Brushes
Nos. 2, 4 and 8 filberts

Other Materials
Paint thinner
Scraper
Palette Knife

Artist's Quality Oils

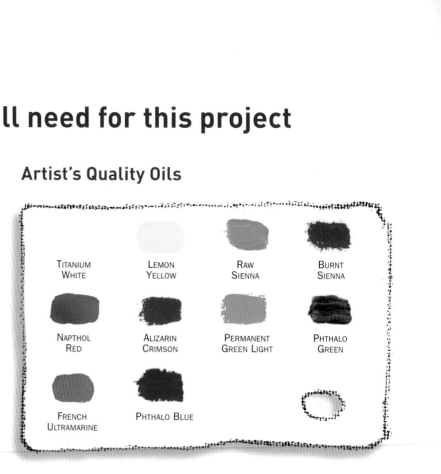

TITANIUM WHITE

LEMON YELLOW

RAW SIENNA

BURNT SIENNA

NAPTHOL RED

ALIZARIN CRIMSON

PERMANENT GREEN LIGHT

PHTHALO GREEN

FRENCH ULTRAMARINE

PHTHALO BLUE

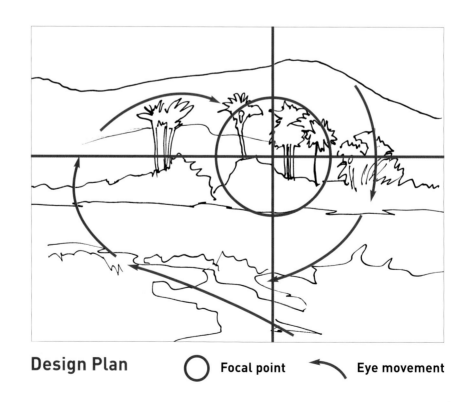

Design Plan ◯ **Focal point** ⤾ **Eye movement**

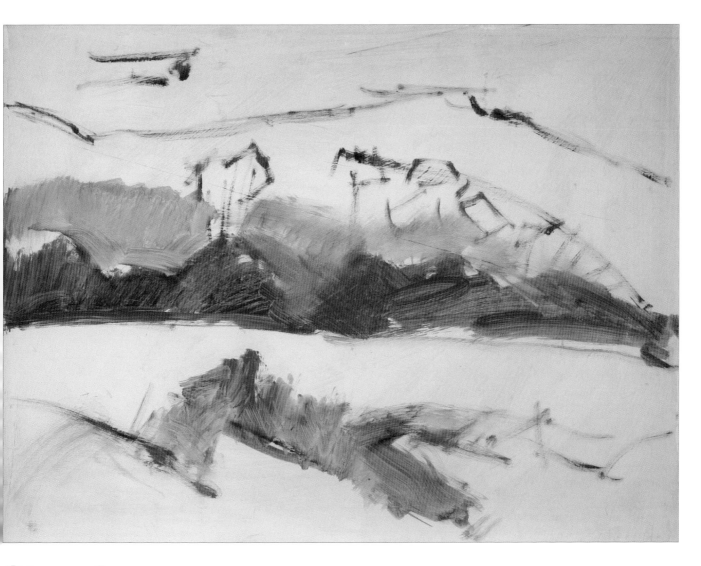

Step 1

Make an outline and introduce the first shapes

- Mix a thin wash of Burnt Sienna and thinner, then using a dry No. 2 filbert lightly draw the outline onto canvas.
- Using a No. 4 filbert, wash a mix of French Ultramarine, Alizarin Crimson and palette gray over the base of the mountain, the tree line and the foreground foliage. There's a natural arch running through the line of the palms.

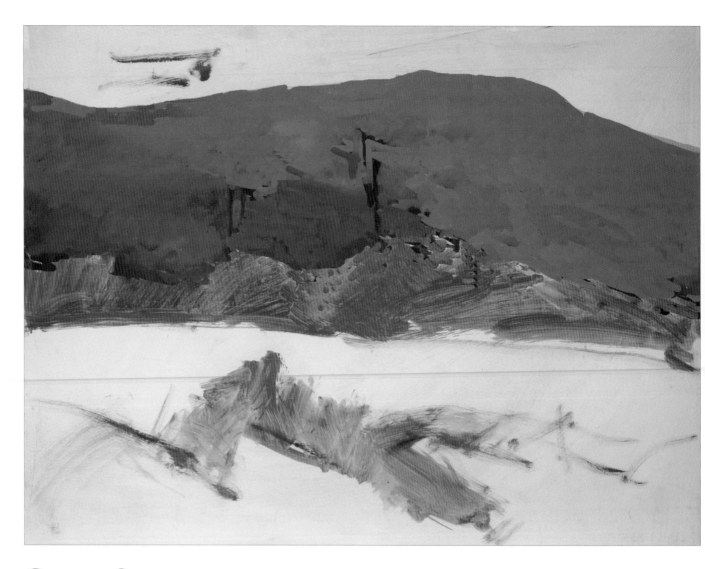

Step 2

Block in the mountain

• Using a No. 8 filbert and a mix of French Ultramarine, Alizarin Crimson and Titanium White, block in the background mountain. Keep it from getting too heavy and dense by adding just enough Titanium White. Paint loosely and outside the lines.

NOTE
Don't try painting in between objects when you have a massive area of color to apply. Lay the color in first, then come back later to detail.

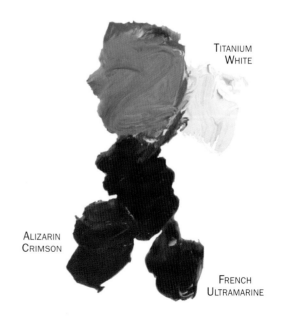

TITANIUM WHITE

ALIZARIN CRIMSON

FRENCH ULTRAMARINE

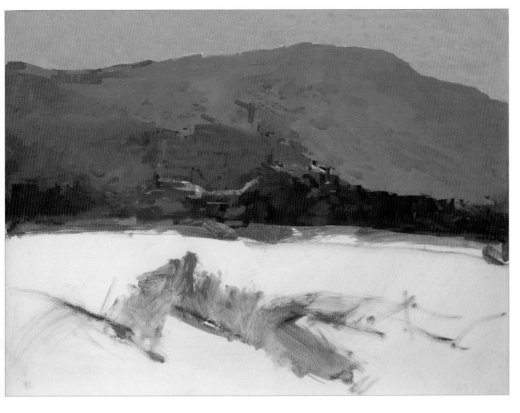

Step 3

Lay in the midground tree line and sky

- Lay in the right side of the sky using a gray mix of Phthalo Green, Raw Sienna and Titanium White. Use Raw Sienna on the left side for a warm effect where the sun is setting and to create interest.

- Block in the shorter trees at the base of the mountain using Phthalo Green, Raw Sienna and colors from the mountain to hold them together and relate them in value. The midground trees have to be close in value because they become less distinct as the sunlight diminishes.

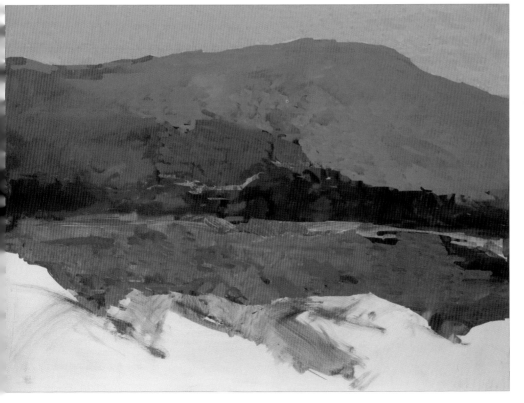

Step 4

Establish the land mass

- Using diagonals to create movement, lay a mix of Phthalo Green and Lemon Yellow in the middle foreground, adding a dash of Napthol Red if it's too green. This land area has more yellow, which will make it appear to advance forward. All ground areas are very close in value at this point.

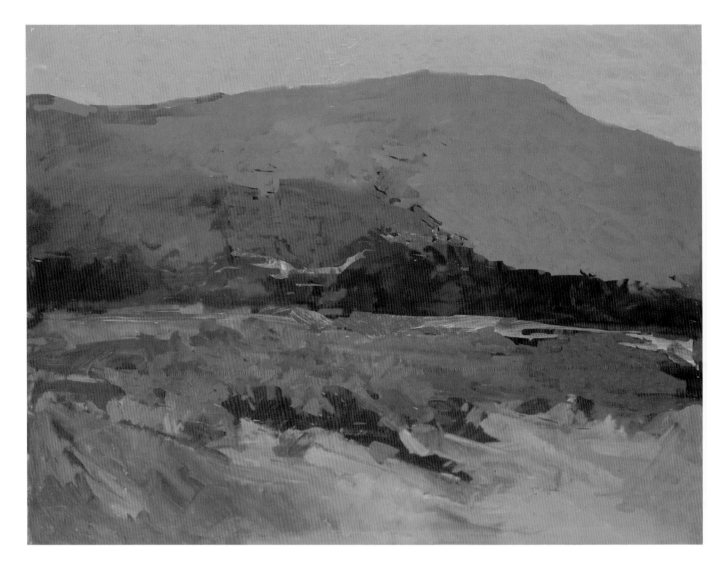

Step 5

Lay in the foreground

- Block in the area of the foreground foliage where it meets the raw soil using French Ultramarine and a touch of Raw Sienna on the left. On the right push the color toward a cooler, lighter mix of palette gray. Keep brushstrokes loose and full of energy.

- Using a No. 4 filbert, apply subtle touches of color to create variety and movement within the grass and soil.

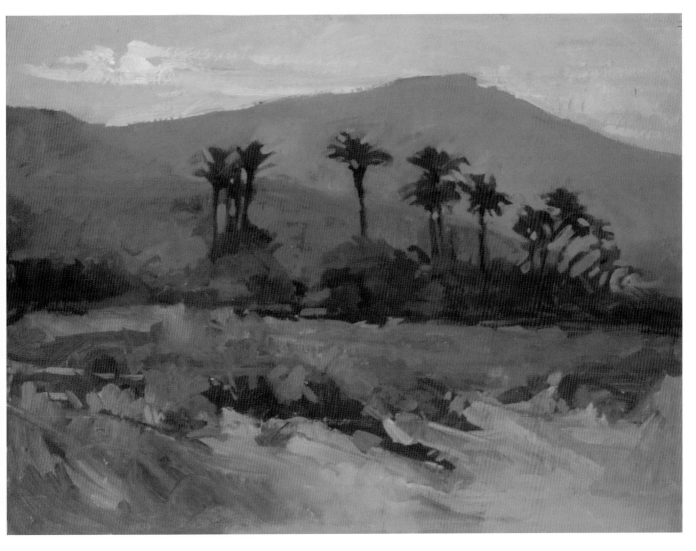

Step 6

Paint the palms and add detail

- Lay in the palms using a mix of darks to create the trunks and an accent of Burnt Sienna in spots. Paint the fronds with a mix of Phthalo Green and a touch of Burnt Sienna as if they're moving in the wind.

- Thinly develop the bushes surrounding the palms, adding some of the mountain color mix to them. Beware of the spaces between the palms.

- Lay in thin faded clouds by using a large dry brush to drag mixes of Alizarin Crimson and Titanium White across the sky. Use the mix with Lemon Yellow and a touch of Phthalo Blue for the left side.

- Add accents and nuances to the sky area. Be sure the values are close so you don't break up the integrity of the space.

The tonal values in this painting

PROJECT 10 FAREWELL TO DESCANSO

Painting impressionistic rocks

This project will show you how to portray the impression of rocks by simplifying them into groups and using depth principles.

The challenges

Painting rocks, especially a pile of them, is often a real challenge. While the task of painting piles of individual rocks may seem overwhelming, remember that your goal is to capture the mood and movement of what you're seeing, not to document every rock you see. Simplify it and the project will be more effective.

What you'll learn

• How to see the overall shapes of groups of individual rocks

• How to keep your composition simple, yet exciting

> **Before you begin, read the entire project through so you know what's going to happen in each stage.**

Foreground

Background

Using Impressionism to paint rocks

The task of depicting rocks in the style of Impressionism begins with grouping them into simple bunches. Look for the large color or value areas that break up the mass of rocks. Determine the values by thinking of how the light hits them, their place in the foreground, midground or background and their proximity to water. For example, as things recede in distance the line under them becomes more straight. As things come toward you they're more defined and open up with a circular shape or silhouette. Identifying the shadows, flat planes and differences of rocks will also help you create dimension.

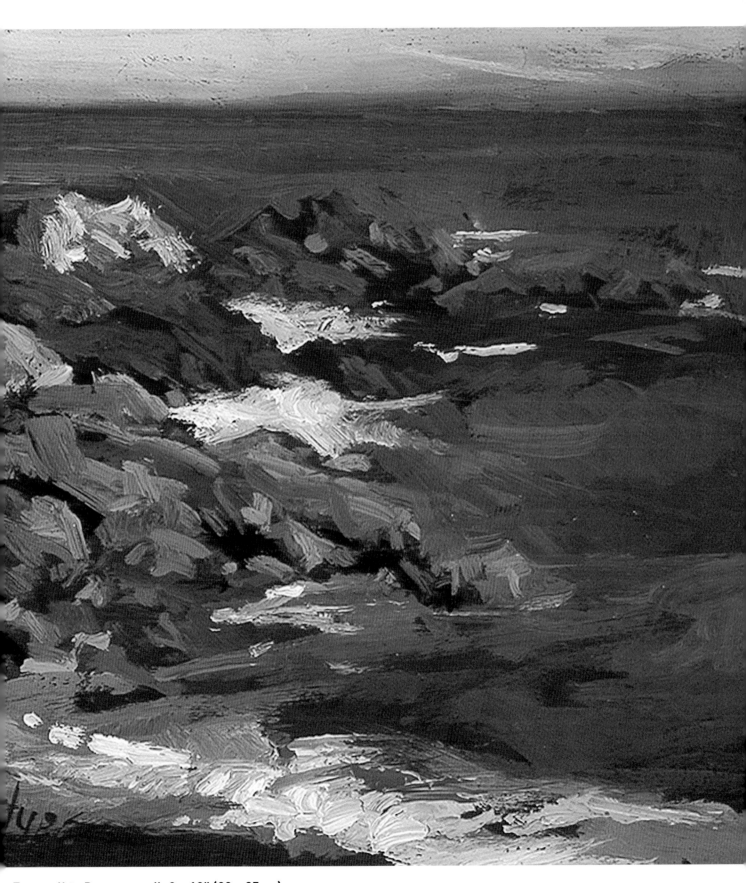

Farewell to Descanso, oil, 8 x 10" (20 x 25cm)

The materials you'll need for this project

Support
Artist's quality canvas board

Brushes
Nos. 2 and 4 filberts

Other Materials
Paint thinner
Scraper

Artist's Quality Oils

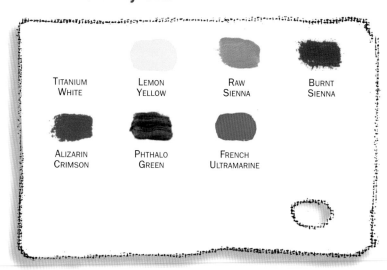

TITANIUM WHITE LEMON YELLOW RAW SIENNA BURNT SIENNA

ALIZARIN CRIMSON PHTHALO GREEN FRENCH ULTRAMARINE

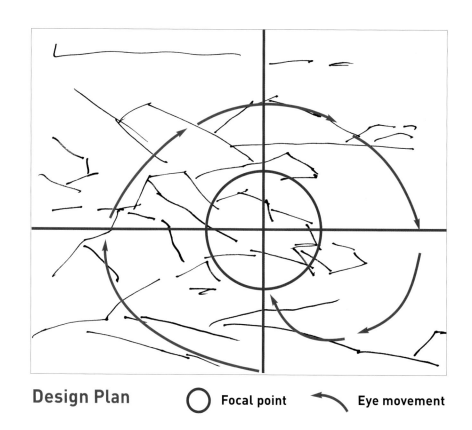

Design Plan ◯ **Focal point** ⬋ **Eye movement**

Step 1
Draw the outline

- Mix a thin wash of Burnt Sienna and thinner, then using a dry No. 2 filbert lightly draw the outline onto canvas. Draw in the different groups of rocks, but remember to keep plenty of room for the ocean area so that it doesn't become a leftover shape.

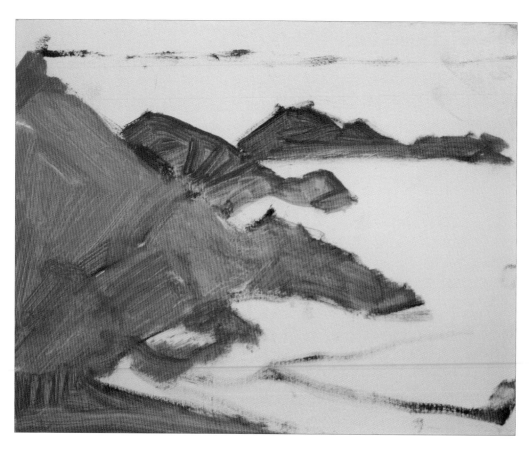

Step 2

Establish rock values

- Using a No. 4 filbert and thin washes, lay in the different groups of rock. For the top triangle use a mix of French Ultramarine, Alizarin Crimson with a little Titanium White. For the other rocks use Raw Sienna and Burnt Sienna, adding a touch of Phthalo Green as the rocks recede.

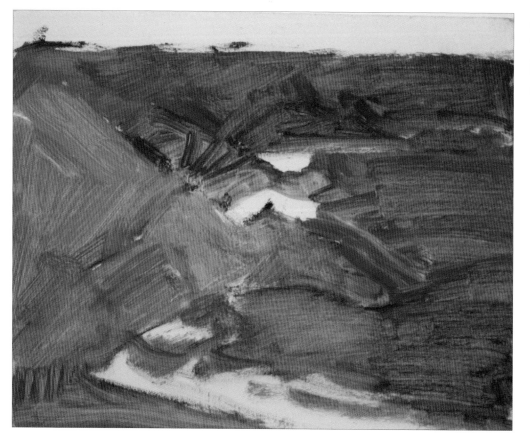

Step 3

Lay in the water

- Using a thin mix of French Ultramarine, Alizarin Crimson and a little Titanium White, lay in the water. The values of the rocks and water are close, especially in the background.

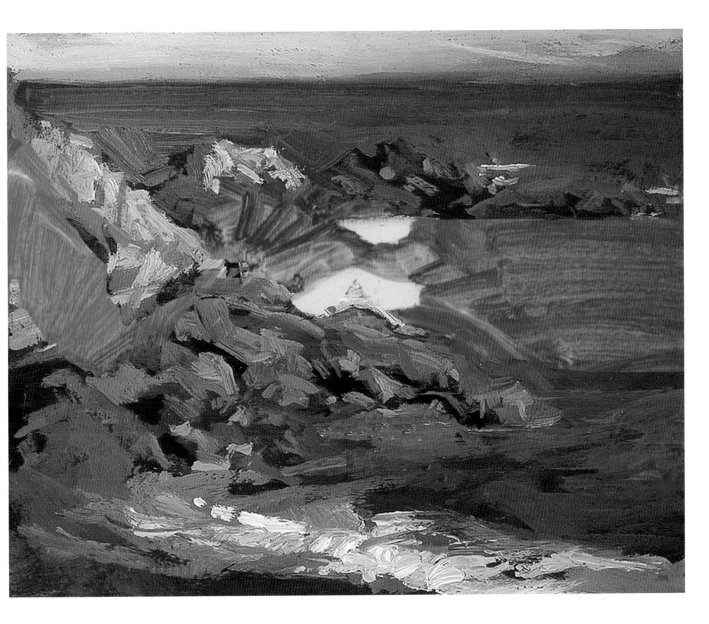

Step 4

Block in individual elements

- You'll use thicker paint for the rest of the painting now that you've thinly covered your canvas. Using a mix of Titanium White and Lemon Yellow, lay in the background sky, adding a touch of Phthalo Green on the left.

- Introduce the hazy land mass at the horizon using a mix of French Ultramarine and Alizarin Crimson. Use the same mix with a touch of Titanium White for the water near the horizon.

- Lay in the top triangle of rocks with a mix of Raw Sienna and French Ultramarine, and paint the distant jutting rocks with Burnt Sienna and Phthalo Green. Make different mixes for different areas, adding a touch of Titanium White and Raw Sienna for the foreground rocks.

- Paint the wave at the shore using a violet mix of French Ultramarine and Alizarin Crimson. Use the water mix with Phthalo Green behind the wave, and add touches of Titanium White for the foam on the shore.

FRENCH
ULTRAMARINE

ALIZARIN
CRIMSON

PHTHALO
GREEN

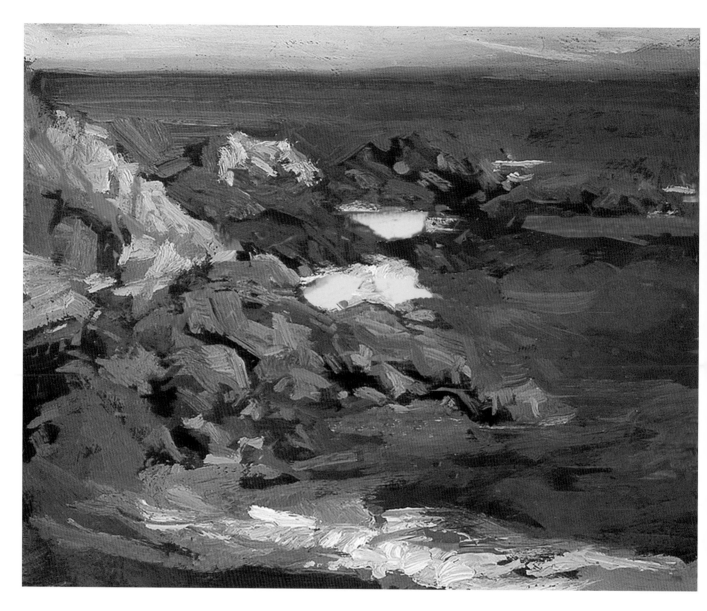

Step 5

Define the water and rocks

- Using loose brushstrokes and a No. 4 filbert, define the water with a mix of French Ultramarine and Alizarin Crimson. Ensuring that the values are close, add accents of greens, violets and siennas to suggest movement and depth.
- Further define the individual rocks, but keep them simple. The whiter rocks keep the rocks separated from the water.
- Begin to lay in the foam crashing against the rocks.

> **NOTE**
> Create interest by playing up differences in the rocks — straight vs. curved, large vs. small and dark vs. light.

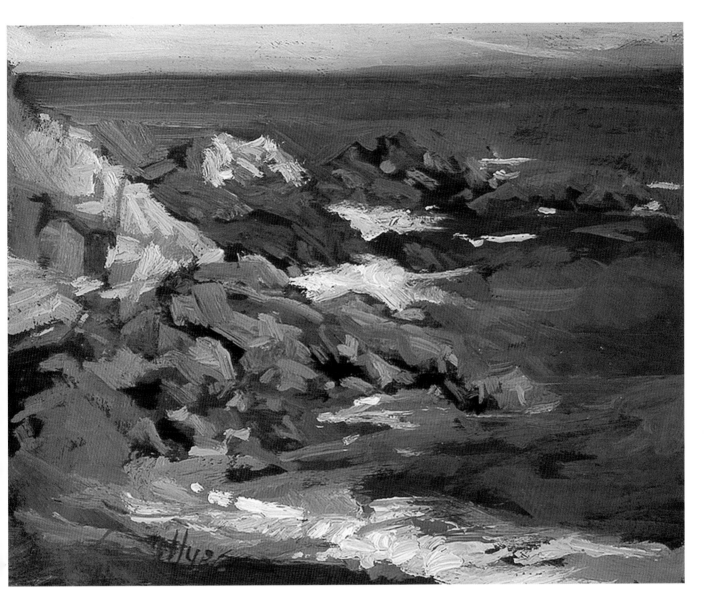

Step 6

Add or subtract for the finish

- Giving them a dash of violet, finish the white foam areas where the water crashes into the rocks. Suggest the soft foam by dragging a clean brush at the edge of the color to soften it.

- Sharpen or eliminate any elements that need it. Your brushstrokes will appear more apparent if the color below is brushed in a different direction. Turn the painting upside down to see if you have a nice variety of shapes.

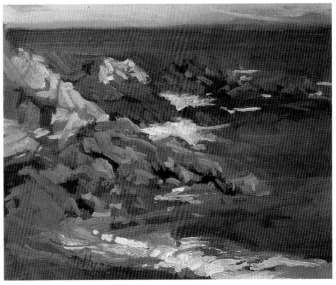

The tonal values in this painting

LEARNING POINTS FOR PLEIN AIR PAINTING

☑ Design/composition

The foundation of any painting is the design or composition. Starting with the finish before getting a good layout is like hanging curtains in a house that hasn't been built yet.

- The first choice of design is the size of support, which is proportioned from height to width. The vertical or horizontal format also has a large effect on the final statement.
- Always keep the Golden Section as your primary layout because it defines where you place elements. This is the principle of dividing your space in thirds from the top to bottom and thirds from the right to left. Visually you'll have two vertical and two horizontal lines that are in equal distance from both sides. The focal point should be near one of these intersecting lines, and the eye movement should revolve around these four points. This also applies to breaking up space within the composition.
- Contrast is important in a good design. Whenever possible use the contrast of large vs. small, detail vs. no detail, warm vs. cool, dark vs. light and intense vs. subtle.

☑ Thick and thin paint

A painting that is 100 per-cent thick paint really is nothing more than a thick paint painting; however, this doesn't mean that people can't do it successfully.

- The secret is to play thick paint against thin, with one dominant and the other subordinate.
- You can create greater interest by using a palette knife for specific areas in the foreground, very light areas or select areas.

☑ Hard and soft edges

To create the effect of space, distance and importance, play hard edges against soft edges.

- Soften the edges and values if you don't want to spend a lot of time in any particular area.
- Elements in the distance should have softer edges than those in the foreground, unless the area in the distance is of major importance, then you can actually reverse this idea.
- Softening edges between elements gives the eye an easy passage from one shape to another.
- Hard lines require that your eye jump to different areas; however, if you have too many jumps the viewer gets tired.

☑ Opaque pigment vs. transparent light

How do you capture translucent plein air scenes when working with opaque oil paint? Matching color to color and value to value will give you what most artists capture, but if you want to capture what you see in my work, then you have to understand the relationships that make something appear to be what it is.

- When working in the sky, be sure to use mostly transparent pigments like phthalos and roses. Using earth tones like umbers, siennas, cadmiums and even too much white will create an opacity that won't reflect the feeling of translucency that the sky suggests.
- Use pure pigment from the tube, but keep it thin so the white of your panel shows through. This will create a transparent color and is a good way to use dark colors.
- To create lightness in the sky, have objects that are darker, denser and less intense touching the edge for comparison.

☑ Color

To have great color you need to know when NOT to use it.

- The best way to overcome fear of color is to study your pigments by separately mixing each color with the others. Next, mix its complement into it, then mix white into each. After two or three test boards like this you'll have fun with color.
- All colors have a warm or cool temperature. Reds, yellows and oranges are the warmer colors, while blues, greens and violets are the cooler colors. However, within each color there are warm cools and cool warms. For example, a red that leans toward a blue is a cool red.
- Colors only look muddy or chalky when you have them everywhere.
- White added to colors can be excellent unless you use too much. There's a very small shift in having beautiful color or a washed-out, pasty color.
- If you want something to look really light and intense surround it with darker, grayer colors.

☑ Shadows

When shadows are used to dominate your composition, they should cover around 70 per-cent of the painted surface. If you allow light to dominate, use shadows to help hold together the different units within the composition.

- If your environment is cool, then your shadows may appear warmer and vice versa. However, always use warm colors inside the cool shadows and the cool colors inside the warm shadows or you'll create a plastic environment.
- Most of the time, the shadows will be reflecting the sky color or a cooler color.
- The stronger the contrast between the shadow and the sunlit area, the stronger your light source or day will appear.
- The entire area of the shadow doesn't have to be as dark as the edge that touches the sunlit area. This prevents a dense, heavy shadow.
- Try to keep your shadows transparent in 70 per-cent of the area to keep your painting from feeling dense and overworked.

☑ Atmosphere

Atmosphere is created by many layers of air between you and the object you're viewing. The further away the object, the more layers of air and the more it becomes the color and value of the area at the greatest distance. For example, in a sunset situation things will get warmer, becoming more like the sunset colors that surround the distant object.

- The air or sky drops down to the earth, right to your very feet! So if someone viewed you from five miles away in the standard light of day you would become bluer. If you were seen at sunset then you would become warmer.
- Distant mountains that are picking up the late day sun and casting shadows will basically have two colors in close value: warm from the sun's direction and blue from the shadow side. The sky that surrounds them would be green, but have the same value. The atmosphere that far back has a lot of yellow sun rays between you and it and since the mountain appears as the bluest thing back there, the sky appears to be a clear, clean, cool green.
- The old adage that blue recedes and red advances only applies in a normal sunlit day when the subject is surrounded with the cool light from a sky that comes to your feet. However, when the sky warms up at sunset, warmer tones make something recede.

ABOUT THE ARTIST

Knowing that nothing is left merely to good luck or pure talent, Betty J. Billups has a passion to share the knowledge and encouragement she has received over the years with others who want to find their own artistic voice.

As far back as she can remember, Betty has gravitated toward art. A nice twist of fate occurred when she gave a friend a ride to Los Angeles for an interview at the Art Center College of Design. When her friend's interview was over, she asked to be interviewed and ended up graduating from the institution.

On graduation day her beloved instructor Joseph Morgan Henninger told her, "I think you'll soon discover that you've barely scratched the surface." In less than ten years, Betty realized she hadn't even been to the surface yet. That realization led her to study with Dan McCaw for two years where she finally understood what her work had been missing.

Upon graduating from the LAACCD Betty was asked to be Vice President of the Society of Illustrators of Los Angeles (SILA), and was solely responsible for organizing and publishing their annual Illustration West Book, which displayed all the top illustrations created in the western United States. As the show opened and the book was published, she was awarded a trip to St. Louis to document the C9, the medical plane of the United States Air Force.

Upon seeing the painting of the C9, an Army official commissioned her to create a painting of Sacajawea. This commission brought her back into the fine arts and she was offered a solo exhibition at the Montana Historical Society in Helena, Montana for the summer of 1977.

Although she had been painting landscapes since the late '60s, her great passion for plein air painting began in 1985 when Denise Burns, founder of the Plein Air Painters of America (PAPA), invited Betty to be a member. Denise's dream was to not only start the group, but as she shared with Betty, "Wouldn't it be great if small groups all over the country saved the vanishing landscapes of this magnificent nation?"

In 1992, Betty juried the annual prestigious California Art Club Gold Medal Juried Exhibition, along with Joseph Morgan Henninger and Neil Boyl. To date, she has had three solo exhibitions at museums in the Northwest. Her work hangs throughout the United States, along with private collections in Japan, Europe and the Near East.

Betty travels up to four months a year teaching workshops. Her painting travels have taken her to the canals of Venice, the southwestern shores of Ireland, the tropical towns of Mexico and Hawaii and throughout the United States.

Read more about Betty and view her exceptional work at www.bettybillups.com.

What artists want!

If you liked this book you'll love these other titles written specially for you.

Artist's Projects You Can Paint

Each of the 10 thrilling step-by-step projects in these books gives you a list of materials needed, and initial drawing so you can get started straightaway. Dozens of individual color swatches will show you how to achieve each special mix. Clear captions for every stage in the painting process make this a fun-filled painting adventure.

- **10 Artist's Projects**
 FLORAL WATERCOLORS
 By Kathy Dunham
 ISBN: 1-929834-50-0
 Publication date: August 04

- **10 Artist's Projects**
 FAVORITE SUBJECTS IN WATERCOLORS
 By Barbara Jeffery Clay
 ISBN: 1-929834-51-9
 Publication date: October 04

- **10 Artist's Projects**
 SECRET GARDENS IN WATERCOLOR
 By Betty Ganley
 ISBN: 1-929834-53-5
 Publication date: February 05

- **10 Artist's Projects**
 LANDSCAPE STYLES IN MIXED MEDIA
 By Robert Jennings
 ISBN: 1-929834-55-1
 Publication date: February 05

- **10 Artist's Projects**
 WATERCOLOR TABLESCAPES LOOSE AND LIGHT
 By Barbara Maiser
 ISBN: 1-929834-52-7
 Publication date: May 05

Art Maps

Use the 15 Art Maps in each book to get you started now!

Art Maps take the guesswork out of getting the initial drawing right. There's a color and materials list and there are plenty of tit-bits of supporting information on the classic principles of art so you get a real art lesson with each project.

- **15 Art Maps**
 HOW TO PAINT WATERCOLORS THAT SHINE!
 By William C. Wright
 ISBN: 1-929834-47-0
 Publication date: November 04

- **15 Art Maps**
 HOW TO PAINT WATERCOLORS FILLED WITH BRIGHT COLOR
 By Dona Abbott
 ISBN: 1-929834-48-9
 Publication date: October 04

- **15 Art Maps**
 HOW TO PAINT EXPRESSIVE LANDSCAPES IN ACRYLIC
 By Jerry Smith
 ISBN: 1-929834-49-7
 Publication date: December 04

How Did You Paint That?

Take the cure for stale painting with 100 inspirational paintings in each theme-based book. Each artist tells how they painted all these different subjects. 100 fascinating insights in every book will give you new motivation and ideas and open your eyes to the variety of styles and effects possible in all mediums.

- **100 ways to paint**
 STILL LIFE & FLORALS
 VOLUME 1
 ISBN: 1-929834-39-X
 Publication date: February 04

- **100 ways to paint**
 PEOPLE & FIGURES
 VOLUME 1
 ISBN: 1-929834-40-3
 Publication date: April 04

- **100 ways to paint**
 LANDSCAPES
 VOLUME 1
 ISBN: 1-929834-41-1
 Publication date: June 04

- **100 ways to paint**
 FLOWERS & GARDENS
 VOLUME 1
 ISBN: 1-929834-44-6
 Publication date: August 04

- **100 ways to paint**
 SEASCAPES, RIVERS & LAKES
 VOLUME 1
 ISBN: 1-929834-45-4
 Publication date: October 04

- **100 ways to paint**
 FAVORITE SUBJECTS
 VOLUME 1
 ISBN: 1-929834-46-2
 Publication date: December 04

How to order these books

Available through major art stores and leading bookstores.

Distributed to the trade and art markets in North America by

F&W Publications, Inc.,
4700 East Galbraith Road
Cincinnati, Ohio, 45236
(800) 289-0963

Or visit: www.internationalartist.com